CW00540080

GATESHEAD
From Old Photographs

SANDRA BRACK, MARGARET HALL
AND ANTHEA LANG

AMBERLEY

Acknowledgements

We would like to thank all the people who have helped us in any way while writing this book. We are grateful to Trevor Ermel, Peter Annable, Phillipson & Son and the Progressive Players, Little Theatre for the use of their photographs.

Special thanks to Duncan Hall for his restoration work on a lot of the images, Jenifer Bell and Maggie Thacker at Gateshead Central Library, Julian Harrop at Beamish Museum and Gary Malkin at The Baltic Centre for Contemporary Art for their assistance with images.

First published 2015

Amberley Publishing
The Hill, Stroud
Gloucestershire, GL5 4EP

www.amberley-books.com

Copyright © Sandra Brack, Margaret Hall and Anthea Lang, 2015

The right of Sandra Brack, Margaret Hall and Anthea Lang
to be identified as the Authors of this work has been asserted
in accordance with the Copyrights, Designs and Patents Act 1988.

All rights reserved. No part of this book may be reprinted
or reproduced or utilised in any form or by any electronic,
mechanical or other means, now known or hereafter invented,
including photocopying and recording, or in any information
storage or retrieval system, without the permission in writing
from the Publishers.

British Library Cataloguing in Publication Data.

A catalogue record for this book is available from the British Library.

ISBN 978 1 4456 4680 0 (print)
ISBN 978 1 4456 4681 7 (ebook)

Typesetting and Origination by Amberley Publishing.
Printed in the UK.

Contents

Introduction

Gateshead Local History Society has been in existence for over fifty years. Three members of the society have researched the photographs and accompanying information for this title.

Sandra Brack has been interested in local history for over thirty years and has written an extensive book about Gateshead's grand houses. Margaret Hall was a broadcast assistant for the local BBC TV station and is currently researching local men who died in the First World War. Anthea Lang was formerly Local History and Heritage Manager for Gateshead Council and has written four local history books.

In this book, which looks at Gateshead through the twentieth century, we have selected many previously unseen photographs to illustrate each decade, with a few familiar photographs along the way.

Gateshead changed enormously during the twentieth century. Riverside slums gave way to high-rise housing blocks and new housing estates, some in outlying areas of town. Earth closets were replaced by flush toilets and medical services improved with the addition of new hospitals and clinics, greatly benefitting the health of Gateshead's residents.

The twentieth century also saw the demise of the electric tram system which had served the town well for fifty years, but it also saw the introduction of the Metro light rail system which provides fast and frequent services to Tyneside and Wearside. Five new bridges were built spanning the Tyne to enable faster road and rail access.

The old iron and chemical works disappeared as did the railway engineering sheds, factors which caused severe unemployment in Gateshead. The answer came in the form of Great Britain's first trading estate on previous marshy ground at the Team Valley.

Gateshead has also seen its old high street shops largely demolished and replaced by a then state-of-the-art shopping centre which has also now been replaced by an even newer model.

Culturally, a public art programme developed in the 1980s. It led to the conversion of a flour mill to a contemporary art gallery and the building of the iconic Angel of the North on the site of a former pithead baths. Gateshead was also chosen as the site of the fourth National Garden Festival in 1990.

GLHS
Gateshead Local History Society

Chapter 1

1900–1909

The beginning of the twentieth century saw the end of the Victorian era and the beginning of the new freer Edwardian age. Gateshead, with its roots in Roman times, was a busy town in 1900 with many of its population engaged in the local ironworks or employed at the North Eastern Railway at Greenesfield. Unfortunately, most of these industries were already in decline and by the end of this decade many of Gateshead's workers would be unemployed. There were new and exciting developments, especially in transport, with Gateshead's steam trams being replaced with electric power. The opening of the new King Edward VII rail bridge also meant improved rail travel. There was a substantial increase in housing stock in areas such as Low Fell, Redheugh and the Teams although this would be the last full decade when the ubiquitous 'Tyneside flat', the Victorian answer to overcrowding, would be built.

Another answer to overcrowding was the opening of Saltwell Cemetery in 1905. This became Gateshead's second 'civic', as opposed to church cemetery and has successfully straddled the century. It is still in operation today.

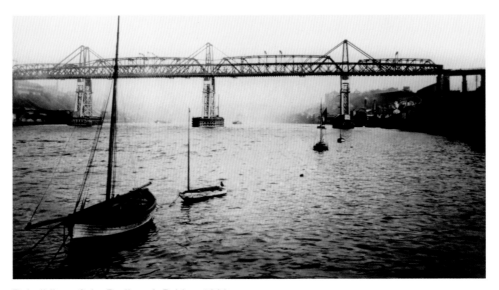

Rebuilding of the Redheugh Bridge, 1900
The first Redheugh Bridge was built between 1868 and 1870 but needed frequent repairs, which meant that within a few years of opening a new bridge was needed and this was built around the old one. In this picture the inverted 'Vs' are part of the old bridge; the rest of the structure is the new bridge.

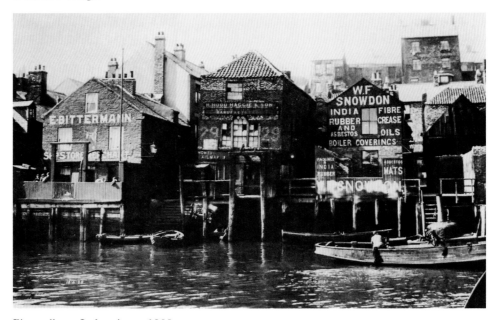

Pipewellgate Industries, c. 1900
As the new century dawned, the Pipewellgate area still housed many of Gateshead's riverside industries as it had done since a century before. It would certainly not have been a pleasant place to walk along as manure works, tripe factories, and lime works all polluted the atmosphere. Shown on this photograph are Bittermann's ships chandlers, Hood Haggie's rope works and Snowdon's boiler-covering premises who mostly had their own mooring points on the river.

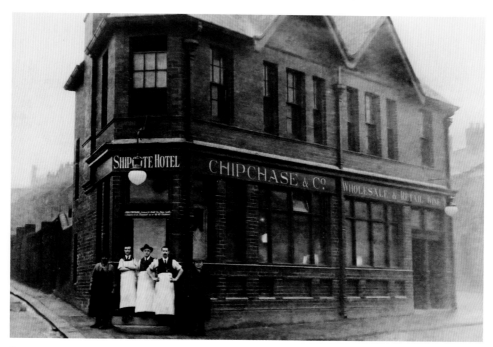

Shipcote Hotel, *c*. 1900

This photograph shows the staff of the Shipcote Hotel situated at the corner of Sunderland Road and Sunderland Street. It was given its name because it was originally near to the Shipcote Colliery. The owners were Chipchase & Co. Mr Chipchase may be in the centre of the photograph with his two barmen on either side. For obvious reasons, the pub was often simply referred to as 'Chippies'.

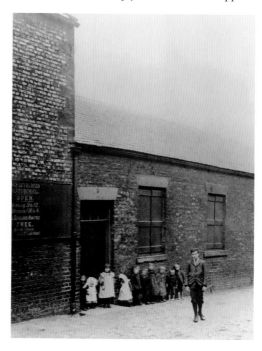

Methodist Chapel and Board School, High Level Road, *c*. 1900

This plain little building was originally a Methodist chapel but was leased temporarily to the School Board in 1872 as there was no other school for the children who lived in the Pipewellgate area. The chapel finally closed its doors in 1894 but the property was retained and eventually sold to the Education Authority in around 1913. The buildings were demolished in the late 1930s and the site was converted to a car park. Luxury apartments (Ochre Yards) now occupy the site.

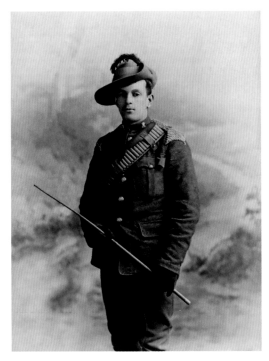

Henry Wadge, Boer War, 1902
Henry served in the 33rd Imperial Yeomanry as a trooper during the Boer War (1899–1902), although he probably only saw service towards the end of the war. His father, the rather unlikely named Agrippa Wadge, was a coal man and Henry worked for his father for some years. The family lived in St Cuthbert's Road, Bensham. Henry survived the war and returned home to Gateshead, eventually dying in 1958 aged seventy-five.

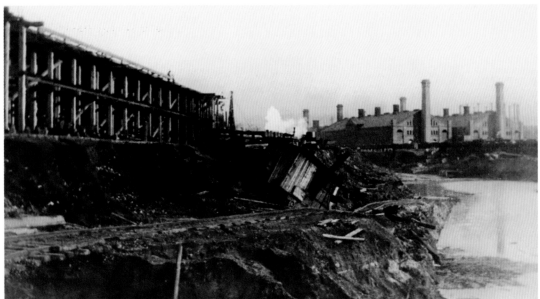

Flooding at Dunston Staithes, 1903
The staithes opened in 1893 to serve the growing coal export industry. A trackway carried wagon-loads of coal which were loaded through chutes by teamers onto ships moored alongside. Built of North American pitch pine, they cost £210,000. In 1903, it was decided to create a parallel set of staithes, but after a tidal basin was dug out one end gave way. By 1911, more than 20 million tons of coal and coke were being exported from the River Tyne. The staithes are reputedly the largest surviving wooden structure in Europe.

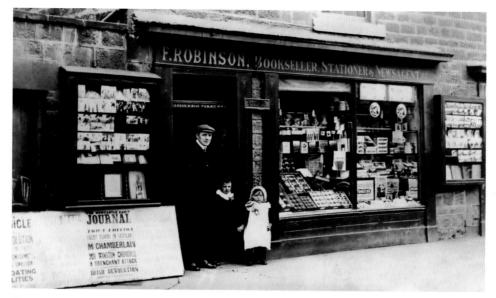

Fred Robinson's Newsagents, Low Fell, 1903

Fred's shop was situated at No. 28 Durham Road, Low Fell and he, his wife Annie and their five children lived above the shop. Fred's previous experience before opening the shop was as a postman. In the case to the left of the door a variety of postcards are displayed – at this period they were the equivalent of today's texts and emails. With up to four deliveries and collections every day, the postman was a frequent sight on Gateshead's streets.

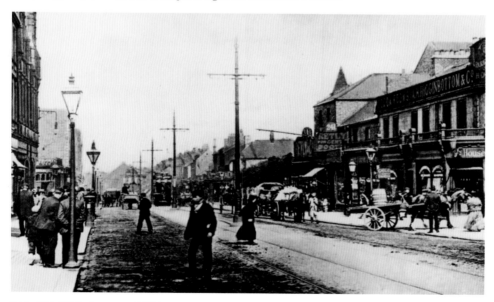

241–251 High Street, c. 1904

There are a variety of shops shown here. On the right in the photograph is Retly's bootmakers with the spire of Holy Trinity church showing above the rooftops. The large building on the right is Higginbottom's wine and spirit merchants. On the other side of the road is the Metropole Theatre and Hotel with the lower building on the opposite corner being the Atlas Hotel.

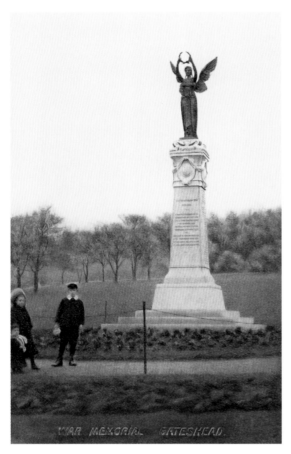

South African War Memorial, 1905
A number of Gateshead men enlisted in
the Boer War and this 26-foot-high war
memorial, surmounted by a bronze statue
of Peace, was unveiled by Sir John French
in Saltwell Park on 11 November 1905. The
memorial commemorates the seventy-seven
men who died in the war, although more
died of disease than of actual war wounds.

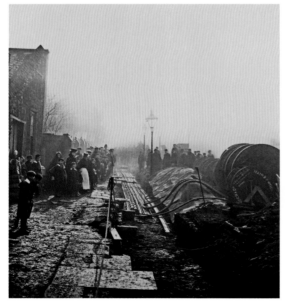

Laying Telephone Cables, Coatsworth
Road Area, 1905
This event brought out the crowds to watch
men laying what would then have been
regarded as 'newfangled' telephone cables
in the Coatsworth Road area. A policeman
is standing in the photograph to ensure that
law and order is maintained. The cable itself
was made by Callender and Co. of Erith,
Kent. Gateshead's first public call box was
situated at the main post office on Prince
Consort Road.

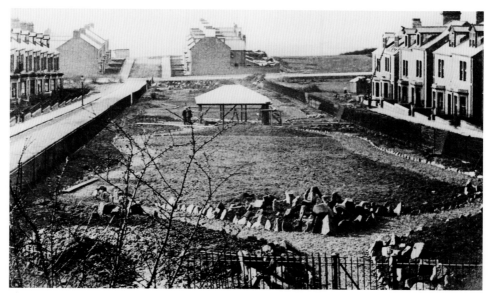

Albert Drive, 1906

In 1906, this private park, designed for the residents of Albert Drive, and the adjoining Myrtle Grove, was formally opened by Alderman Robert Affleck. The original householders subscribed the annual sum of half a guinea towards its upkeep. An acre in size, it was planted with 1,000 trees and shrubs and contained a flagstaff and also a summer house.

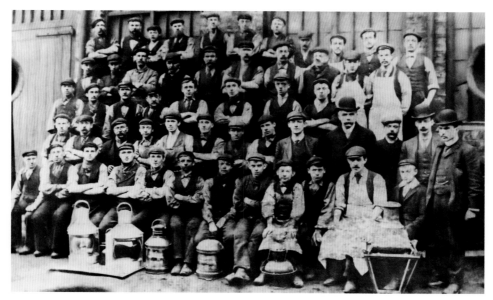

Staff at Clarke Chapman's Engineering Works, 1906

This photograph shows some of the many men who were employed at Clarke Chapman's engineering works, which opened in 1864 as Benning, Clarke & Co. on the South Shore. They took new premises at St James Road in 1874 and began making winches but were soon producing boilers and electricity generating plants for ships. During the twentieth century, they were also involved with nuclear engineering.

Provident Chapel, 1907
Children from the Sunday school of this little chapel are shown here all dressed up for the photographer. The chapel was situated on Old Durham Road, often referred to as Sodhouse Bank. The notice to the left of the door proclaims 'UMFC [United Methodist Free Church] Sunday School anniversary May 5 & 12 1907'.

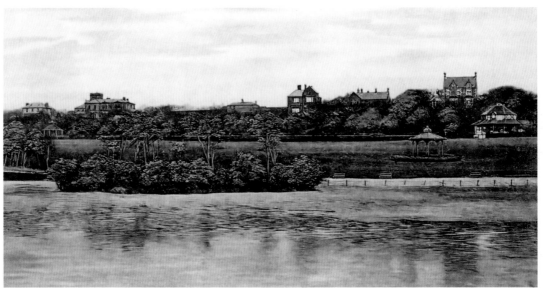

Bandstand, Saltwell Park, c. 1908
This was the second bandstand to be installed in Saltwell Park after the first, installed in 1876, had rotted away. This structure was situated between the lake and the Almond Pavilion and was so popular that the grass around the bandstand was worn away by people walking on it. To solve this problem, the bandstand was moved to an island in the centre of the lake in 1909. When the wind was blowing in the wrong direction, the music was often inaudible.

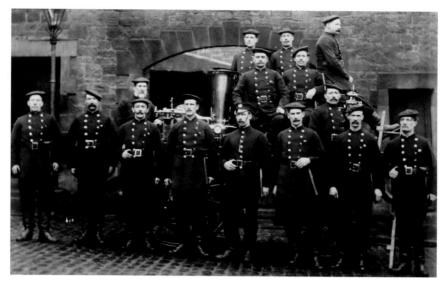

Gateshead's Fire Brigade, c. 1908
In 1904, a new house was bought in Swinburne Place for the chief fireman and, in 1907, a fire station was built at the rear of the Town Hall in Swinburne Place. Here, the men are posing proudly with their rather fetching French beret-style headwear – although it is doubtful how effective they would be when dealing with a fire! Only the chief fireman seems to have a more conventionally styled stiffened cap.

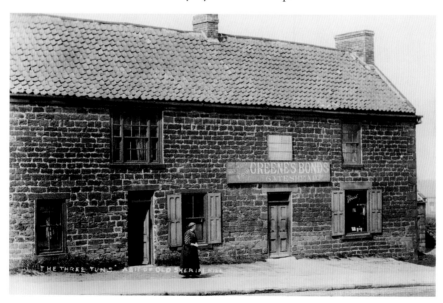

Three Tuns, Sheriff Hill c. 1909
Even in the 1900s, this building was being described as 'a bit of old Sheriff Hill'. The Three Tuns dated back to at least 1828 and was frequented by the many miners and quarrymen who lived in the Sheriff Hill area. In the pub's early days, cockfights were held and nearby in Kells Lane, 'cuddy' or donkey races were run. The building shown in the photograph was demolished in 1923 and replaced by another, which is still in use today.

Chapter 2

1910–1919

A new King, the sinking of the Titanic and the First World War were all major events in this decade. Closer to home, this period saw the formation (and demise) of Gateshead Football Club and the completion and opening of the Shipley Art Gallery – one of very few buildings allowed to be completed during the war. Many men in Gateshead enlisted in the 9th Battalion of the Durham Light Infantry, a battalion which won more war honours than any other during the course of the war. Because many of the men were undersized, the battalion gained the nickname of the 'Gateshead Ghurkhas'. There are a number of war graves in both Gateshead East and Saltwell cemeteries. Two large houses, Whinney House and Saltwell Towers, were converted to hospitals for wounded soldiers.

The industrial slump that had affected Tyneside during the early years of the decade was turned around when war broke out, resulting in an economic boom for the ironworks and railway works.

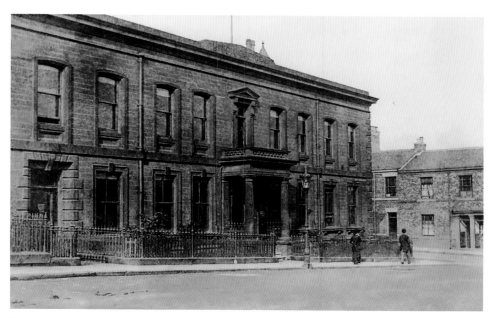

Poor Law Union Offices, Prince Consort Road, 1910

This building was built around 1870 as new offices for Gateshead's Poor Law Union. By the time this photograph was taken, the union was serving a population of 117,000. The board met on the first Tuesday of each month at 3.30 p.m. In 1929 Boards of Guardians were made redundant and their services were taken over by local councils. The building was eventually demolished in 1971.

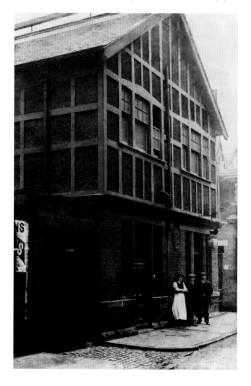

The Fountain Inn, Pipewellgate, 1910

This is possibly the third building of this name to be built on the site and the original was considered to be one of the earliest public houses in Gateshead. This rebuild dates from around 1905 and still stands today (although no longer in use). Pipewellgate was noted for its pubs. In 1782 there were at least six public houses here serving residents, itinerant workers and travellers to Newcastle.

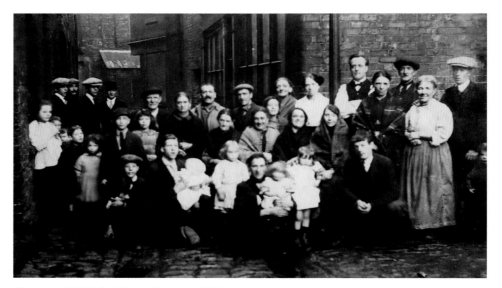

Crown and Thistle, Pipewellgate, *c.* 1910

Another of Pipewellgate's ancient pubs is shown here. The manager, Sam Bell, can be seen along with some of the poorer residents of the area. The building probably dated back to the late eighteenth century and appears to have been demolished in the years following the First World War, at a time when much of Pipewellgate was being cleared of commercial and residential premises.

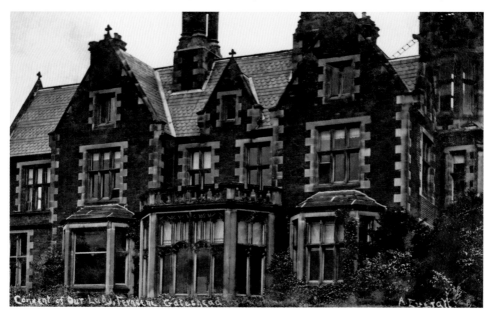

Ferndene, *c.* 1910

The religious society, 'Daughters of Wisdom', otherwise known as the *Filles de la Sagesse*, was founded in France in 1715. Members travelled the world and founded numerous schools. Ferndene House in Saltwell, formerly the home of rope manufacturer Robert Stirling Newall, was converted into one of their schools, known as La Sagesse in 1906. The nuns occupied the building for six years, after which they moved to larger premises at Jesmond Towers in Newcastle.

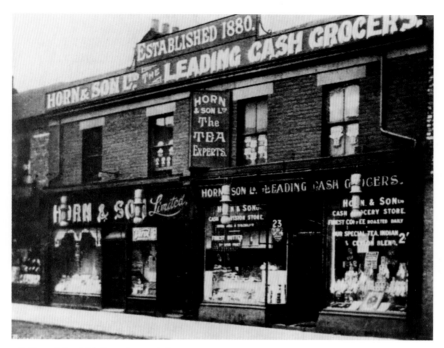

Horn & Son, No. 299 Sunderland Road, *c.* 1910

Sunderland Road was a good shopping street for people living in East Gateshead and Horn's grocery store was one of the largest. Horns described themselves as tea experts and also as the 'leading cash grocers' and their windows hold a wide variety of teas. They had another shop in the Deckham area of town. Note the rather tasteful gas lamps on the exterior of the building.

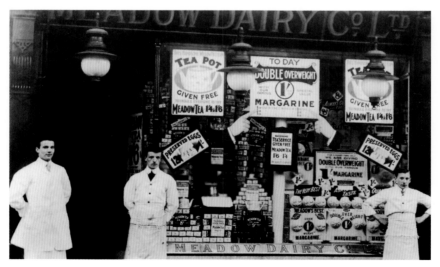

Meadow Dairy, No. 319 High Street, *c.* 1910

The Meadow Dairy was one of a chain of premises in Gateshead operated by the same firm. They began by selling dairy produce but gradually expanded into selling other products. There is a wide variety of inducements being offered in the shop windows to encourage people to buy Meadow tea – these included offering yellow-patterned teapots and tea services.

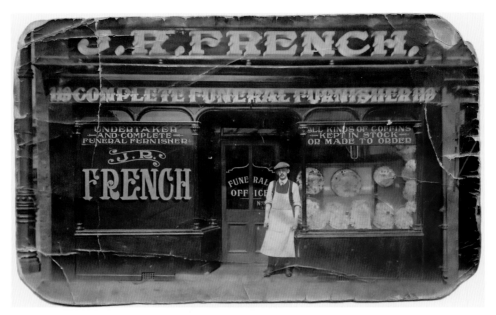

French's Undertaker's Shop, No. 119 Sunderland Road, *c.* 1913

This is probably James Robson French standing outside his shop, one window of which displays his advert 'all kinds of coffins kept in stock or made to order' and is filled with coffin wreaths all made from artificial flowers. Sadly Mr French, who served as a private in the Army Service Corps during the First World War, died as a result of war injuries on 4 December 1917 aged thirty-four.

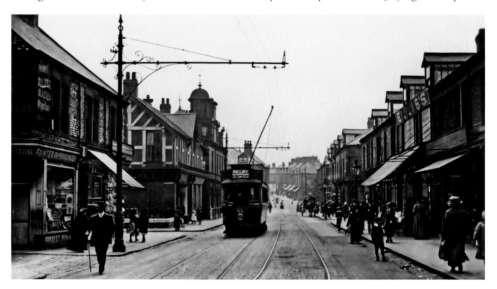

Coatsworth Road, *c.* 1913

Other than Gateshead's High Street, this was perhaps the busiest shopping street in the town and served Saltwell and Bensham areas. On the left the large building with the turret is the Honeysuckle Hotel, with Hawks confectioners the timber edged building. In the forefront on the left is J. A. Forrest's painters and decorators shop, while the large shop with the canopy is that of Ellis's drapers.

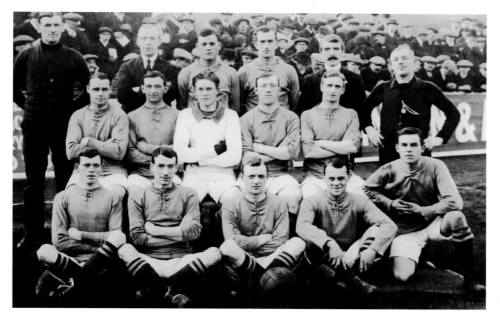

Gateshead Football Team, 1913–14

Gateshead's first football club was Gateshead N. E. R. FC, which was formed in 1889. This was succeeded by Gateshead Town FC who joined the Northern Football Alliance in 1905. Their grounds were the Shuttles in the Teams area and Old Fold Park. The club turned professional in 1911 and although initially attracting large crowds, attendances were in decline when this photograph was taken.

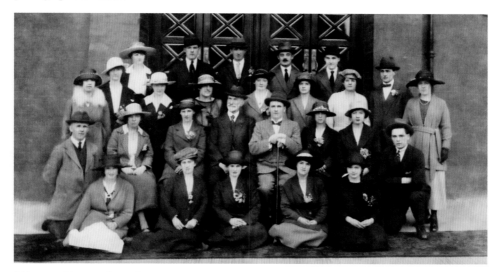

Shipcote Cinema Staff, 1914

This picture hall opened on Durham Road in the Shipcote area in 1911. Designed to provide 'high-class family entertainment', it became noted for its good orchestra. In September 1916, the Shipcote was one of a number of cinemas throughout the country to screen *The Battle of the Somme*, described as 'real war in all its glory and all its horror'. This was a film that shocked the nation although some scenes were staged for the camera.

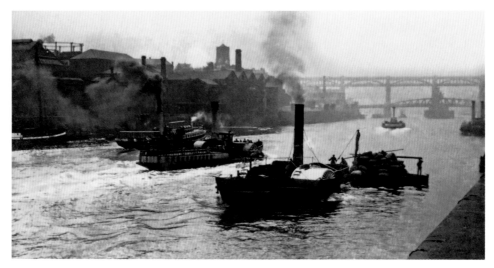

River Scene, 1915

The tower of St Mary's church can be seen high above Gateshead's rather murky hillside in this photograph of the River Tyne taken during the First World War. The two bridges visible here are the Swing Bridge in the foreground with the High Level Bridge behind. Steam powered paddle tugs are busily employed towing various cargoes and the Oakwellgate gasometer can be seen top left.

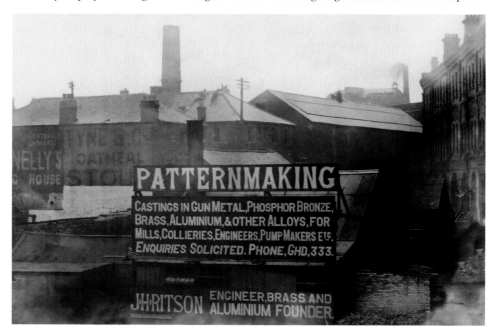

Ritson's, c. 1915

This photograph shows the premises of J. H. Ritson, described as engineer, brass and aluminium founder, which were situated at No. 20 Bankwell Lane. One of Gateshead's early telephone numbers, 333, is displayed on the sign. The firm was founded in the early 1900s by Jonathan Hodgson Ritson who was a JP and was later elected as Mayor of Gateshead for two successive terms between 1931 and 1933. Today, the site is occupied by the Hilton Hotel.

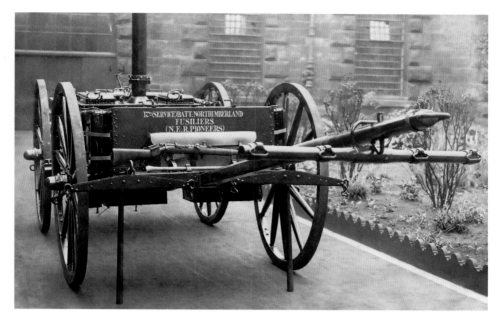

Greenesfield Locomotive Works, *c.* 1915

This vehicle was constructed at the Greenesfield Engineering Works and, although looking like a gun carriage, was actually a mobile field kitchen designed for the 17th Service Battalion of the Northumberland Fusiliers, (N. E. R. Pioneers) during the First World War. The battalion saw service at the Somme in 1916 but was also heavily involved in the construction of railway lines on the Western Front.

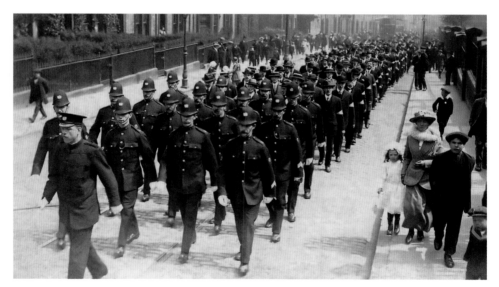

Police and Fire Services Marching up Walker Terrace, 1918

The occasion for this march is unknown – it may have been to celebrate the Armistice. Men from Gateshead's police and fire services are shown marching up Walker Terrace much to the interest of the many bystanders. The right-hand side of the street contained much larger houses than the left-hand side, which was built later (and demolished in the 1970s to make way for a new bus station).

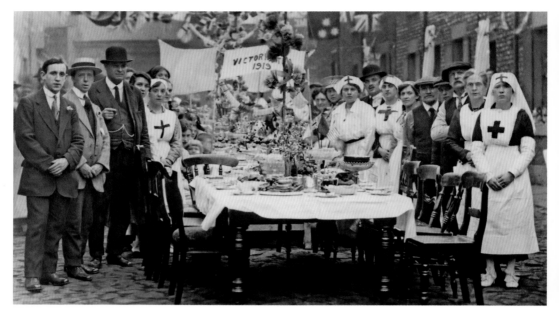

Peace Tea, Riddell Street, 1919

Armistice Day occurred on 11 November 1918, although the negotiations for peace took a further seven months. When peace was finally declared on 28 June 1919 it was another excuse for a street party, and the picture above shows residents of Riddell Street, some of whom are in nurses uniforms.

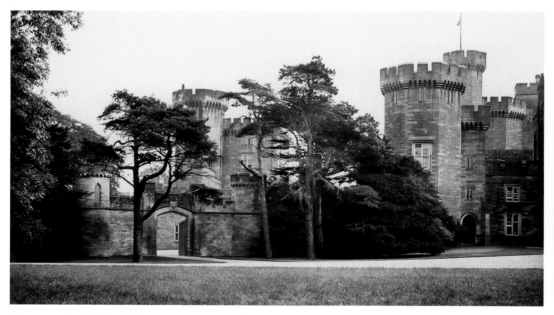

Ravensworth Castle, 1919

At one time the oldest fortified house in County Durham, Ravensworth Castle was situated to the west of Gateshead and since the sixteenth century was home to the Liddell family. Incorporating two medieval towers, the house was later rebuilt. The castle was visited by a variety of illustrious people including the Duke of Wellington and the Archduke of Austria.

Chapter 3

1920–1929

Nationally, the 1920s saw the marriage of the Duke of York (the future George VI) to Lady Elizabeth Bowes-Lyon and the subsequent birth of their daughter Elizabeth. A general strike brought the country to a virtual standstill, and the first talking pictures were shown. In Gateshead, a new Central Library was opened, Saltwell Park was extended, new council estates were built and the Tyne Bridge was built which meant a rerouting of the north end of the High Street and the demolition of a number of buildings. Despite a period of high unemployment, this was an exciting decade for Gateshead.

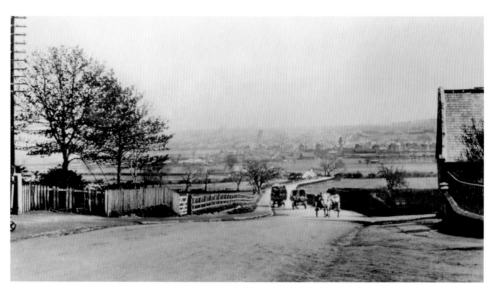

Lobley Hill, 1920

Taken from what is now Lobley Hill Road, this photograph presents us with a very tranquil scene of days gone by. Looking across to Gateshead, most of the photograph is of a rural scene with horse-drawn vehicles. It is difficult to believe that within fifteen years of this photograph being taken, a lot of the green space shown here would be built upon, both by housing and also by the Team Valley Trading Estate.

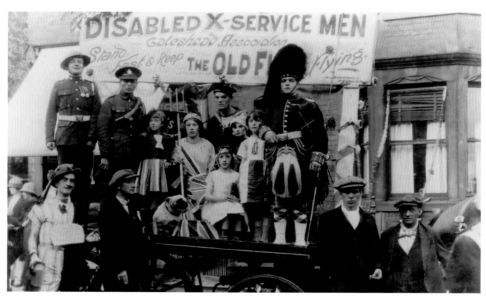

Disabled Ex-Servicemen, 1920

Gateshead lost approximately 1,700 men in the First World War. The majority served either in the Northumberland Fusiliers or the Durham Light Infantry. For those who returned, often disabled, life could be hard. Employment was limited and in many cases men remained unfit for work for the rest of their lives. This picture shows a float used as part of an appeal for funds to help these men.

Hermitage Gateway, *c.* 1920
The Hermitage was once home to William Clarke, co-founder of Clarke Chapman's engineering firm. The gateway shown here was reputedly dismantled by Richard Grainger from Anderson Place in Newcastle, which he demolished in the 1830s to make way for his Graingertown development. The gateway stood at the entrance to the Hermitage for many years. The building was later taken over by High Fell Workingmen's Club in 1920.

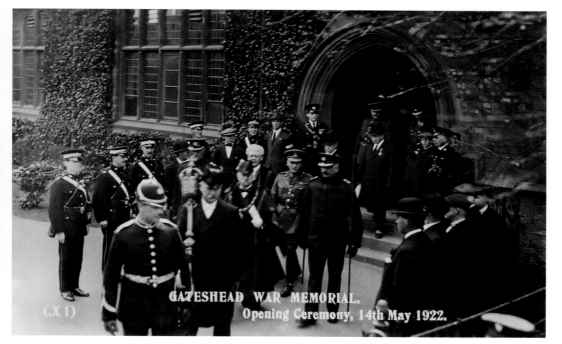

Opening of the Cenotaph, 1922
Gateshead's first large memorial to men who died in the First World War was unveiled on 14 May 1922. Here the civic party, led by the Chief Constable, the Mace Bearer, the Mayor Sir John Maccoy, the Town Clerk William Swinburne and Major General Sir Percy S. Wilkinson (who would formally unveil the memorial) leave Gateshead Secondary School on their way to the formal ceremony.

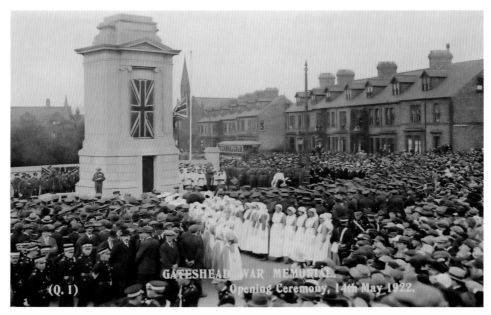

Unveiling of the Cenotaph, 1922

The union flag covers the statue of a 9-foot-high warrior depicting 'manhood' in an attitude of 'defence' with an unsheathed sword. Four men of the Durhams (the Durham Light Infantry) stand guard. Inside the cenotaph, designed by J. W. Spink, was placed a book of remembrance. The whole cost was raised by public subscriptions. A large crowd, including many former soldiers and nurses, gathered for the ceremony.

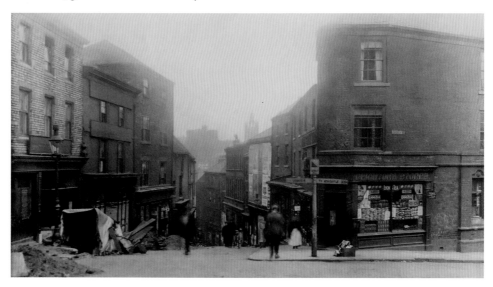

Bottle Bank, 1924

The junction of Church Street and Bottle Bank is shown here. Both streets were later affected by the building of the approach road to the Tyne Bridge but work had not yet started when this photograph was taken. The signpost points right to Newcastle but left to 'Danger' – this was Bottle Bank, which was so steep that, in the eighteenth century, Church Street was built to bypass it.

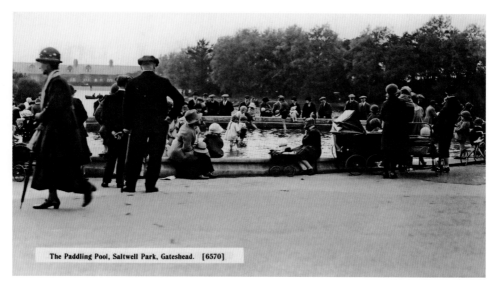

The Paddling Pool, Saltwell Park, Gateshead. [6570]

Paddling Pool, Saltwell Park, 1925

The new paddling pool which opened in the park in 1925 is a hive of activity in this postcard. The prams seen in the foreground of the photograph were originally banned from Saltwell Park – an early bye-law prohibited all wheeled vehicles. The resultant outcry from parents of babies and young children meant the ban on prams and wheelchairs was quickly rescinded.

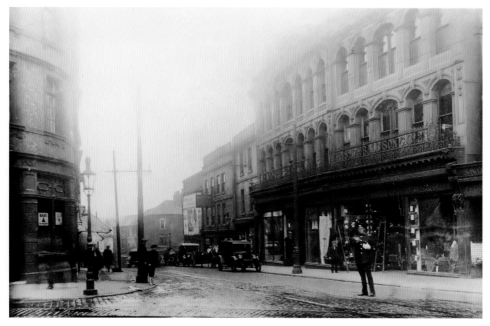

Nos 1–25 High Street, 1925

Here are some of Gateshead's largest shops, most of which were demolished for the construction of the Tyne Bridge approach road. The large shop on the right is Snowball's department store. As a result of the road being built its whole frontage was demolished and the shop moved 30 yards back. This resulted in a severe loss of business and Snowball's eventually closed in 1940.

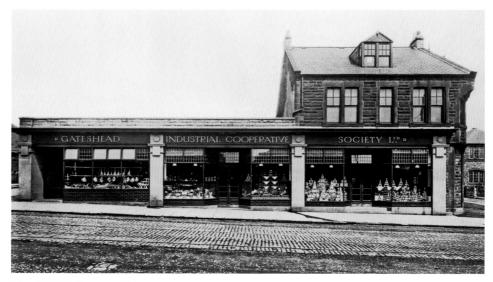

Sheriff Hill Co-op *c.* 1925

The Co-operative stores were some of the most extensive shops on Old Durham Road, often called Sodhouse Bank, but today known as Sheriffs Highway. The left-hand store was the butchers, with a dairy and grocers alongside. The building immediately to the right of the shops was one of the early council houses built in this area during the 1920s.

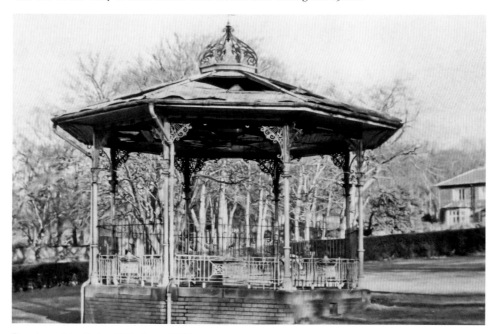

Bandstand in Saltwell Park, *c.* 1925

After its rather unfortunate period of banishment on the island in Saltwell Park, the bandstand was moved to the area of the park known as 'the Grove'. It took its name from the house seen at the rear of this photograph. The estate (apart from the house) was bought by Gateshead Council in 1921 as an extension to the park.

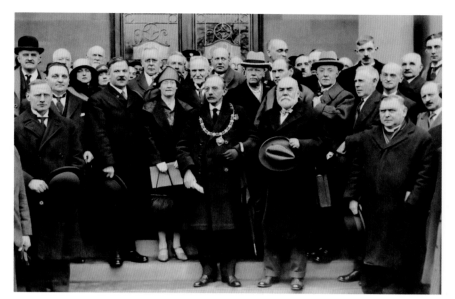

Opening of the Central Library, 6 April 1926
Gateshead's new library was set in the residential area of Shipcote where it was hoped it would attract a better class of customer than had visited the original library in Swinburne Street in the town centre. The new library was formally opened by the Earl of Elgin, chairman of the Carnegie United Kingdom Trust, which provided a grant toward the building costs.

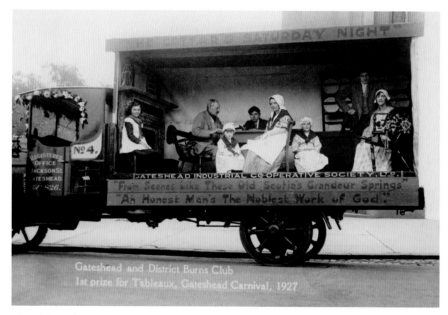

Gateshead Carnival, 1927
Gateshead held its first annual carnival in 1927 and the photograph above shows the winning entry from the Gateshead and District Burns Club. It depicts 'The Cotter's Saturday night'. The Burns club was a very popular institution in Gateshead with over 200 members at this time and regularly held dances, whist drives and other activities.

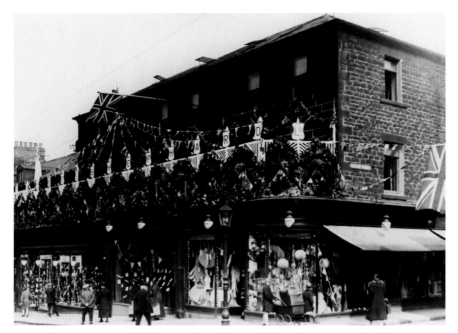

Shephard's Store 1927
This store, at the corner of West Street and Ellison Street, became Gateshead's most well-known department store. It began in 1906 as a boot and shoe store opened by Emerson Shephard in Swinburne Street, which was so successful that two years later he had moved to these premises which he extended in 1924 with the addition of a drapery section. The store is shown here decorated for Gateshead Carnival.

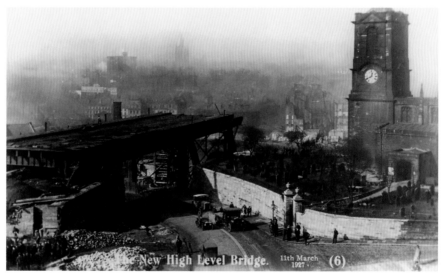

Construction of the Tyne Bridge, 11 March 1927
The building of the Tyne Bridge, which opened in October 1928, was a notable event in Gateshead as it involved the wholescale demolition of a number of buildings around the area of its approach road. Many shops at the bottom of Gateshead High Street disappeared as did the east side of Bottle Bank.

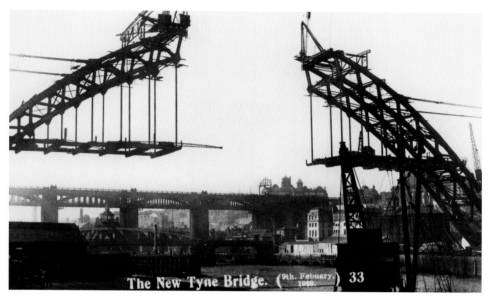

Tyne Bridge under Construction, 1928

An iconic photograph showing the two sides of the arch of the bridge almost meeting in the middle. The bridge was completed on 25 February 1928 although it would be a further eight months before it would be formally opened. Designed by the firm of Mott, Hay & Anderson and built by the Middlesbrough firm of Dorman, Long & Co., the bridge contains a staggering 777,124 rivets.

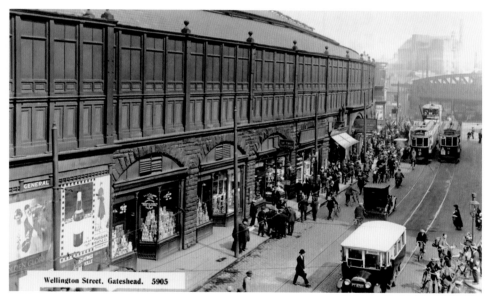

Wellington Street c. 1929

A busy street, with pedestrians, cyclists and trams intermingled. The arch at the far end of the street was the entrance to Gateshead East Railway Station. The large shop shown is the Co-op with its windows filled with attractive displays advertising teas, coffee, cocoa and Pelaw polish while centre photograph is a sign advertising 'The first baccy shop'. The tall chimney of Tucker's brewery on Swinburne Street can just be seen at the top right of the photograph.

Chapter 4

1930–1939

This was the decade of the three Kings. George V died, his son and successor Edward VIII abdicated and it was left to King George VI to take the country into the 1940s. It was also a period of economic difficulty with high unemployment and hunger marches taking place throughout the country. In Gateshead, hopes of employment hinged on schemes designed to provide some temporary employment such as the creation of the rose garden in Saltwell Park. However, in 1936 it was announced that Gateshead would be the site of the United Kingdom's first-ever trading estate. This was sited at the Team Valley, an area of marshy ground which involved a comprehensive drainage programme. Its success gave Gateshead new hope for the future.

Abbot Memorial School, 1930

This imposing building was built in 1869 to house up to 150 boys and girls (although it soon became boys only), found committing petty offences, vagrancy or thought to be at risk of committing crimes. The school was founded by the widow of John George Abbot, the owner of the Park Ironworks. Due to falling numbers, the school closed in 1930. The building was later used as Thompson's Red Stamp Stores.

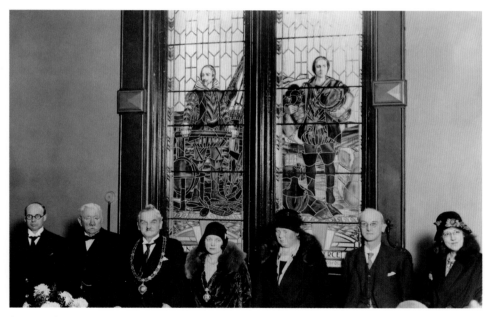

Stained Glass at the Town Hall, 1930

Second left on this photograph, taken in the council chamber, stands the donor of this lovely stained-glass window, Sir John Maccoy, who was mayor of Gateshead eight times. In 1930, not only did he present these windows but he also received the Freedom of Gateshead. A shipping magnate, he lived at Springfield House on Durham Road, Gateshead. The windows, produced by the Gateshead firm of Thompson & Snee, represented his interests in commerce and industry.

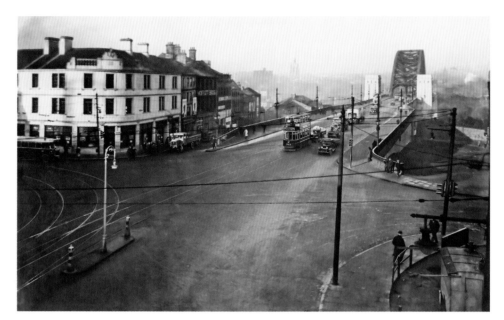

Tyne Bridge Approach Road, *c.* 1930

Even though the buildings on the left of the photograph have all been demolished, this still remains a recognisable scene today. Trams, lorries and cars can all be seen here at the Tyne Bridge. The street running off to the left is Half Moon Lane and the Half Moon public house is the large building on the corner at the top of Bottle Bank.

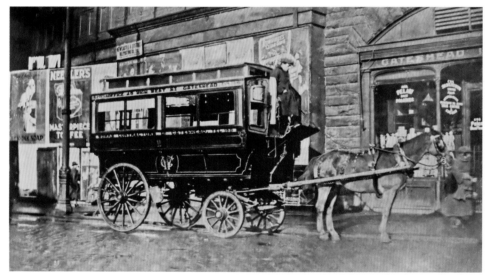

Horse Brake on Wellington Street, 1931

The 'Ha–penny lop' was the only form of public passenger service to operate on the High Level Bridge until electric trams crossed the bridge. Foot passengers had to pay a halfpenny fare while the fare for the horse brake, carrying up to forty passengers, was only fourpence, which resulted in a reduced income for the toll collectors. This photograph was probably taken as a souvenir of the service, which ended in June 1931.

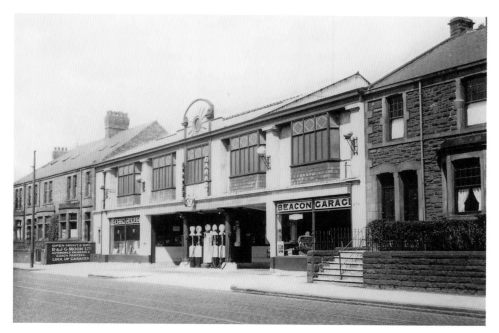

Beacon Garage, Durham Road, *c.* 1933

Ralph Moon started this business in the early 1920s with his two sons, John George and Willie. They took the name of the garage from the street where they lived: Beacon Street in Low Fell. Although they seem to have had little previous experience of the motor trade, they made a success of the business and it was a feature of Low Fell's Durham Road for many years. It is still a garage today.

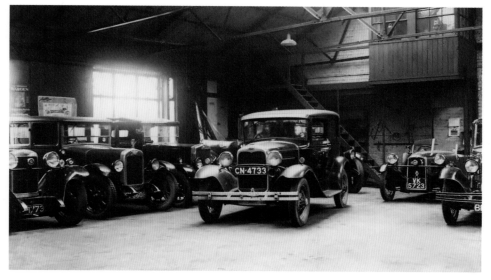

Interior of Moon's Garage, *c.* 1933

The interior of the garage shows a variety of cars, probably available for sale although some may be in for repair. The CN registration shown on the front vehicle was issued for cars registered in Gateshead while the VK prefix on the car behind was only used between 1929 and 1933 for Newcastle-registered cars. Moon's office can be seen on the mezzanine level.

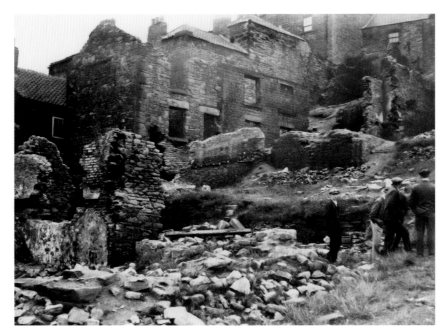

Rabbit Banks, 1934

The Rabbit Banks were a continuation west of Pipewellgate on Gateshead's quayside. Their housing was about as poor as Pipewellgate's and in the 1930s there was wholescale demolition of the area. Before industry came to Gateshead, the banks here were overrun by rabbits, hence the area's name. This photograph was taken shortly after a wall had collapsed, injuring a young boy called Thomas Oliver.

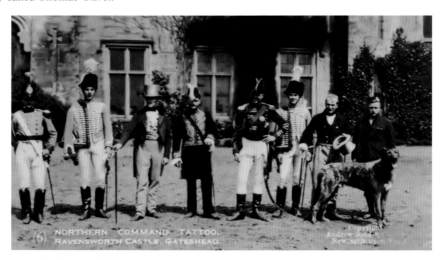

Ravensworth Tattoo, 1934

Ravensworth Castle became a girls' school for a while after the family moved out. In 1934, a military tattoo was held at the castle with a series of tableaux. The photograph above depicts the commemoration of the visit to the castle of the Duke of Wellington and Sir Walter Scott in 1827. The tattoo was repeated in 1936. While hugely popular events, the organisers were accused of encouraging militarism.

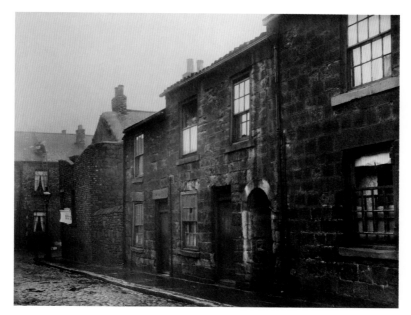

Nos 24–26 Leonard's Court, *c.* 1934

Leonard's Court was widely regarded as one of Gateshead's worst streets and dated back to the 1830s. It became one of the areas in town where Irish immigrants settled and became representative of Gateshead's worst kind of living conditions as it had no drains and no water standpipes. The street was eventually demolished during Gateshead's slum-clearance programme in the 1930s.

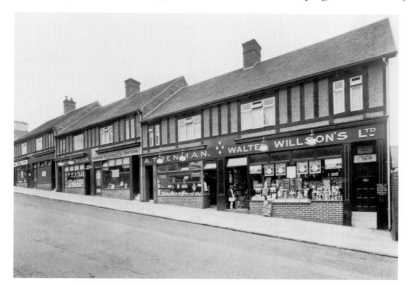

View of Shops on Beaconsfield Road, Low Fell, 1935

Beaconsfield Road contained a mix of shops for Low Fell's discerning shoppers. These included Penman's butchers and Walter Willson's grocers, while at Correlle Beauty Culture the stylists would have aimed to produce the curls and waves so necessary for the 1930s fashionable ladies who could order their tailored costumes from Hugh Dolan whose premises are at the very right-hand edge of the photograph.

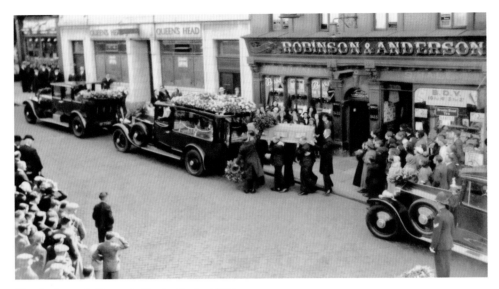

Tot Anderson's Funeral, Bottle Bank, 1936
On the day destined to be the burial day of Tot Anderson, the well-known and popular landlord and owner of the William IV public house on Bottle Bank (adjacent to the Queen's Head shown here), crowds gathered in force along the short downhill route to St Mary's church where the burial service was held. The actual burial took place at Gateshead East cemetery.

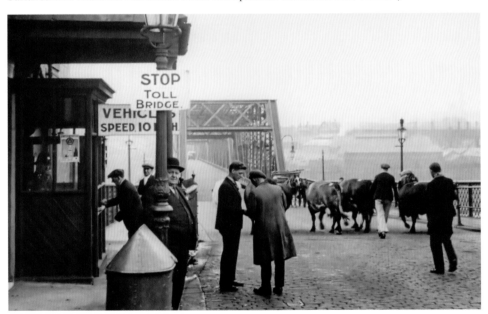

Traffic on the Redheugh Bridge, 1937
This photograph of the Redheugh Bridge was taken before tolls were removed on Coronation Day 1937, a day described as 'the north's greatest Coronation gift'. Here, cattle are being herded across to the cattle market close to Marlborough Crescent in Newcastle. Hopefully none will violate the 10 mph speed restriction in operation! The toll keeper appears to be temporarily sharing his booth with a policeman.

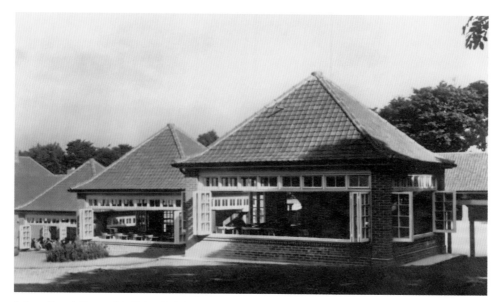

Joicey Road Open-Air School, 1937

On the continent, the benefits of fresh air to improve health had long been advocated and as the twentieth century dawned, this movement spread to England. Gateshead's only open-air school opened in Low Fell on 20 May 1937. It was designed to educate 'physically handicapped and delicate' children. All children were expected to have an afternoon nap outdoors unless it was raining, in which case all the windows and doors were opened.

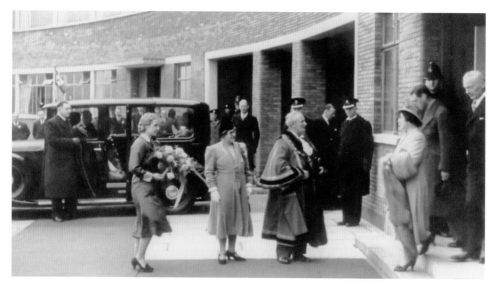

Opening of the Team Valley Trading Estate, 1939

This estate was the first of its kind to be built in this country and was planned to encourage an economic and employment revival in Gateshead with its emphasis on a variety of light, rather than heavy, industries. The site took time to develop as the ground was marshy and subject to frequent flooding and the River Team had to be especially culverted through the centre of the estate. It was opened on 22 February 1939 by King George VI.

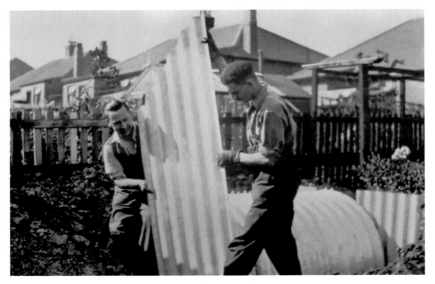

Erecting an Anderson Shelter in Oakfield Road, 1939

Preparations for war were well under way in Gateshead from around 1938 onwards. On 25 February 1939, 450 steel shelters were delivered to Gateshead with unemployed men used to erect them. However, there was some resistance to this scheme as many people did not want to spoil their garden by that erecting a shelter might never be used. Those who were not thought of as 'at risk', and earning more than £250 per year, were charged £7 but the shelters were free for other people.

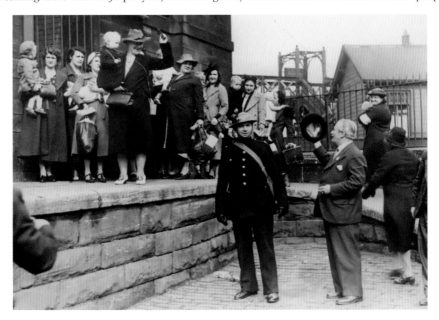

Evacuation, 2 Sept 1939

The Mayor of Gateshead, Cllr William Pickering, is seen here waving off children from Gateshead West railway station. Children from Gateshead were evacuated to North Yorkshire, to areas such as Richmond and Leyburn, and for many (and for many of their Yorkshire hosts) this was a complete culture shock. Within a few months, most children had returned back home to Gateshead.

Chapter 5

1940–1949

The Second World War, the inception of the National Health Service and educational reform were all major features of this decade. In 1936, a housing survey had shown Gateshead to be the second worst county borough in England with nearly 16 per cent of its people living in overcrowded conditions. This situation became even worse during the period of the Second World War as people from severely bombed areas came to live with their relatives in Gateshead – a town which suffered very little from air raids. Indeed, only one stick of bombs fell and that was in Saltwell Park. During the war, Gateshead's Little Theatre opened, which was possibly the only theatre to open in England during this period. The end of the war saw new ideas and hopes for transport, housing and education. These would all come to fruition in the following decade.

Ravensworth Terrace, *c.* 1940

Here a young man stands outside his house in Ravensworth Terrace. The threat of glass being blown out when any bombs were dropped resulted in many householders liberally taping over their windows to prevent glass fragments injuring the inhabitants.

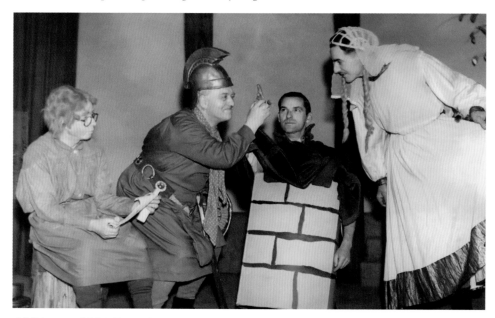

A Midsummer Night's Dream, Little Theatre, 1943

The Little Theatre was opened on 10 October 1943 by the Mayor, Mary Gunn. The theatre owed a great debt to sisters Hope, Ruth and Sylvia Dodds who provided the money to buy a vacant site and the house next door on Saltwell View. The first production, which ran from 13–16 October 1943, was Shakespeare's *A Midsummer Night's Dream* with music performed by the Bensham Settlement Orchestra.

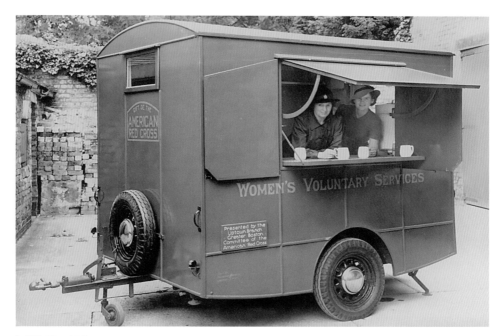

WVS Food Van, *c.* 1943

The Women's Voluntary Service was established in 1938 and played a major role during the Second World War, organising help such as evacuation, clothing, food and first aid. Here Mrs Wilson and Mrs Godwin from the Gateshead branch are shown in their mobile food van in the grounds of Ashfield House, then being used by the Civil Defence Corps. The van was presented by the Uptown branch of the Greater Boston Committee of the American Red Cross.

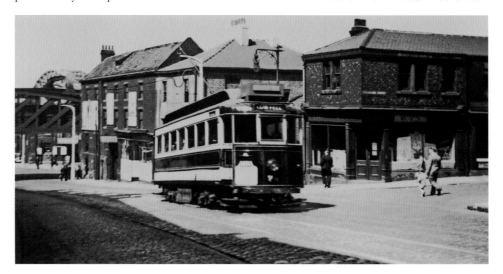

Low Fell Tram on West Street *c.* 1943

The Low Fell tram begins its climb up West Street en route to its terminus just past Chowdene Bank. The junction with Swinburne Street is shown here. This street was named after the Swinburne family of Gateshead who were notable landowners and two of the family, father and son, held uninterrupted positions as town clerk from 1856–1929. The shop at the junction is a WVS shop.

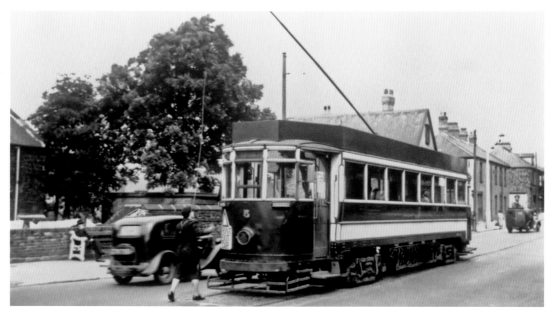

Tram on Durham Road, 1944

Here the tram conductress is changing the trolley pole at the Low Fell terminus, just past the junction of Durham Road and Chowdene Bank. The original terminus was actually at the junction but during wartime, it was feared that traffic collisions could be caused here due to the blackouts imposed. The tram here is shown in its wartime livery.

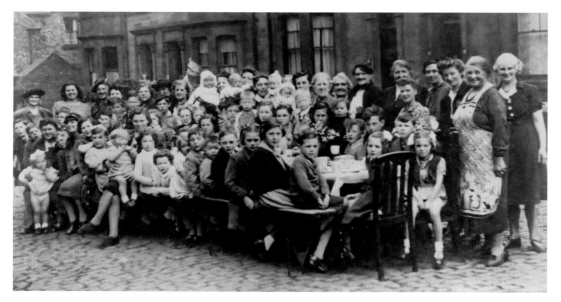

VE Day Party, Exeter Street, 1945

8 May 1945 was declared Victory in Europe day and a public holiday was declared. The Germans were vanquished, the threat of invasion had disappeared and for the residents of Exeter Street it provided a good excuse for a party. All children in the neighbourhood were invited with the ladies of the street creating tempting cakes, jellies and sandwiches – a miraculous feat as rationing was still in force.

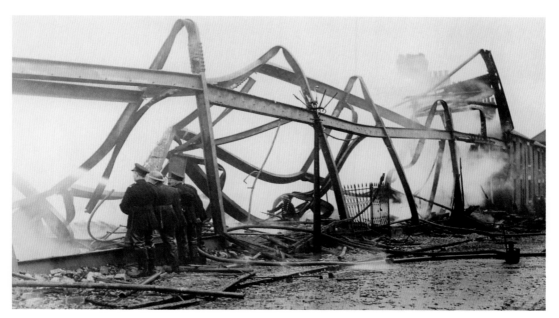

Fire at Shephard's Store, 18 January 1946

On 5 January 1946, one of the worst fires on Tyneside destroyed Shephard's department store along with all its stock. Many people thought that the fire meant that the store's days were now ended. Emerson Shephard, however, had other ideas: he refused to be beaten and immediately began organising temporary facilities in the former Snowball's shop on Church Street.

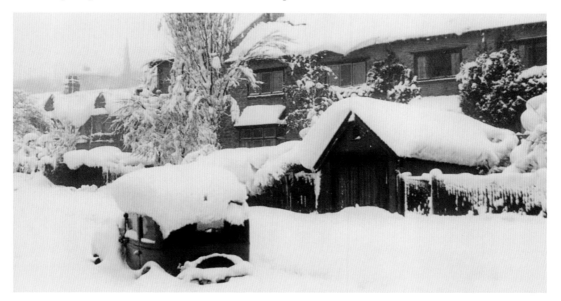

Denewell Avenue, Rear of Kells Lane, 1946

The winter of 1946/47 is now widely regarded as probably the worst this country has ever known. Traffic was brought to a standstill, there was a national fuel shortage and within three months almost 7 feet of snow had fallen over the country. The photograph above shows houses and cars on Denewell Avenue in Low Fell in undated in snow.

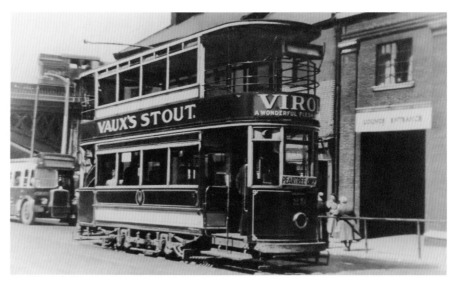

Sunderland Road Tram, 1947
The tram shown here, standing outside the Dun Cow public house at the north end of the High Street, operated on the Sunderland Road route where it terminated at the Gateshead boundary near to the Peartree public house. Behind the tram is a United bus and on the bridge is a VI tank locomotive.

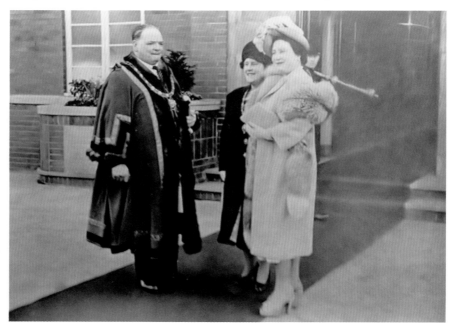

Visit of Queen Elizabeth to the Queen Elizabeth Hospital, 1948
18 March 1948 saw the opening of the Queen Elizabeth Hospital. Originally opened as Sheriff Hill Infectious Diseases Hospital, extensions were first planned in 1939 but then put on hold due to the outbreak of the Second World War. The hospital opened a maternity unit in 1944 with nearly 650 births recorded in the first year. Queen Elizabeth (later the Queen Mother) also visited the Shipley Art Gallery on the same day.

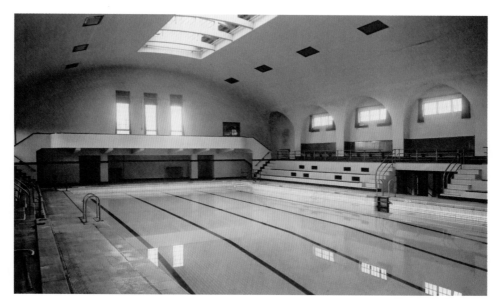

Shipcote Baths, 1948

The official opening of Shipcote baths was on 29 April 1942 and were the only swimming baths to be opened in England during the war. They were designed by the borough surveyor, Fred Patterson, in a simple streamlined design and had a feature barrel-shaped roof and large pool capacity of 130,000 gallons of water. The foundation stone was laid on 24 July 1939 – only six weeks before war was declared.

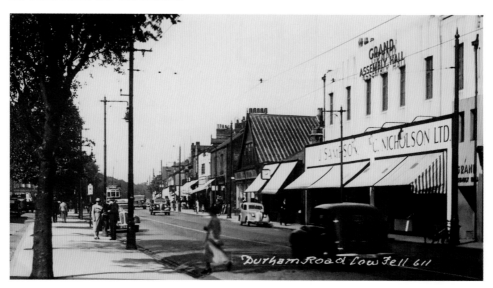

Durham Road, Low Fell, 1948

Durham Road in Low Fell has always been a popular shopping venue with a wide variety of shops to choose from. J. Sampsons was a family-run greengrocers who had also another shop on Coatsworth Road, while C. Nicholson's was a fresh fish shop. This scene gives us a nice mix of building styles. The Assembly Hall shown above the shops opened in the late 1930s and for some years was a popular attraction.

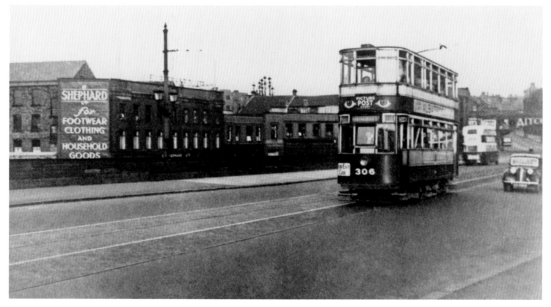

Tyne Bridge Approach Road, 1948
Shephard's temporary store is clearly shown here with a tram, destined for the Haymarket, Newcastle, travelling north on the Tyne Bridge approach road. Shephard's used this store, once home to Snowball's – another famous Gateshead department store, until their new store was opened in Ellison Street in 1951.

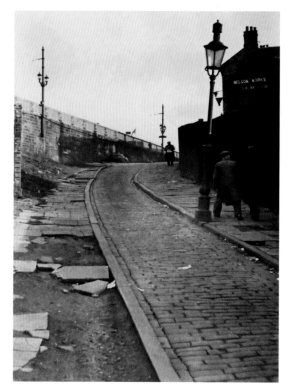

Bottle Bank, 1948
When the Tyne Bridge approach road was built, the whole of the east side of Bottle Bank was demolished and the bank slightly rerouted. Its steepness, however, remained, as did its general air of dereliction, which had never been remedied since the destruction of its east side. The Nelson works of J. Dingwall & Son can be seen in front of the Queen's Head public house.

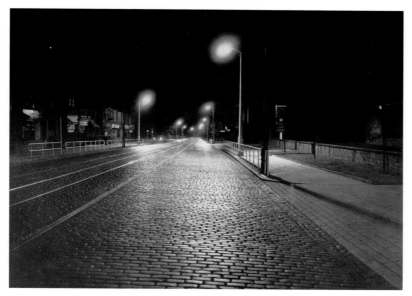

Durham Road, Shipcote, *c*. 1948

A night-time scene of Durham Road at Shipcote with no traffic to disturb the landscape. The streetlights illuminate the granite setts of the road surface. Note the Belisha beacons on either side of the road. This photograph was taken just before the introduction of zebra crossings to accompany the beacons. Until 1949, crossings like these were denoted by sets of parallel studs in the road.

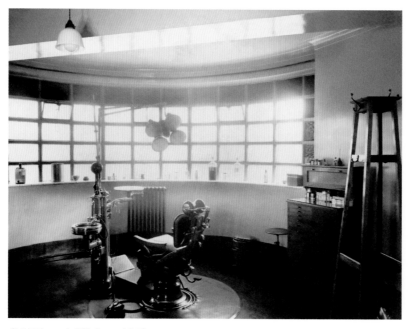

Greenesfield Dental Clinic, *c*. 1949

The dental chair, complete with its gas and air machine, stands waiting for its next victim. Greenesfield clinic was purpose built on Mulgrave Terrace in an Art Deco style (note the curved window shown here) in 1938 and cost £16,048 to build.

Chapter 6

1950–1959

When Queen Elizabeth II ascended the throne in 1952 on the death of her father King George VI, Britain was set for a new Elizabethan age. Austerity turned to prosperity as the decade went on and there were new trends in housing, fashion and entertainment with television rising in popularity as the sets became more affordable.

This became the period of Gateshead's 'brave new world'. Overcrowded housing conditions were eased by the introduction of the first high-rise flats on Tyneside. Trams were replaced by conventional motor buses, new schools were built and a new shopping centre was planned. These were exciting times but also challenging as people had to come to terms with all these new developments.

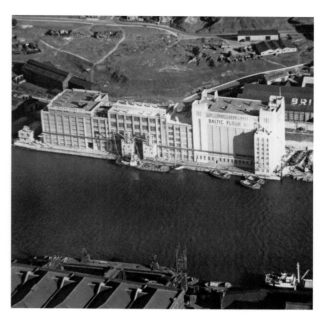

Baltic Flour Mill, 1950
Planned to be built pre-war, Joseph
Rank's Baltic Mill did not open until
1950. The building cost £1,500,000.
The premises were extensive, covering
81,000 square feet and 240 tonnes of
grain could be produced per hour. The
wheat came mainly from the West
Cumberland Farmers' Co-operative
and was delivered by sea and then
unloaded straight into the mill. An
animal feed mill was added in 1957.

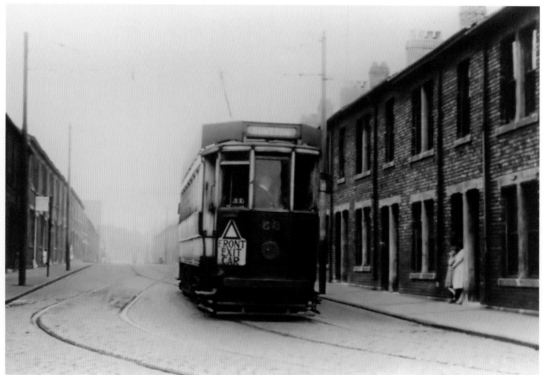

Pine Street, 1951
4 August 1951 saw the end of fifty years of electric tram service in Gateshead. The last tram route to
operate was the Dunston line and the photograph above shows a front exit tram making one of its last
journeys along Pine Street.

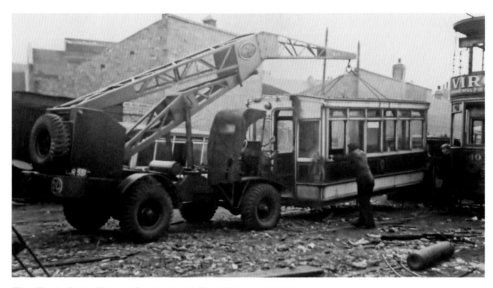

The End of the Trams, Sunderland Road Depot, 1951

Once the last tram had run, disposal and destruction of most of the vehicles then followed. Some ended up as temporary farm buildings in Northumberland, while others were sold to the Grimsby and Immingham Light Railway. Within two years the last of the tram lines, once such a familiar feature on Gateshead's streets, had disappeared.

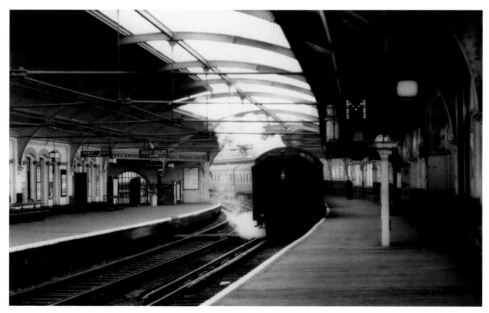

Gateshead East Station, 1952

The steam train heading out of the station is travelling towards Newcastle having started its journey from the Sunderland direction. This station was rebuilt during 1884 to 1886 and survived almost until the introduction of the Metro light railway system in 1981. Electric trains ran to and from South Shields every twenty minutes during the day in this decade but, until 1958, the occasional steam train could be seen en route to either Sunderland or Middlesbrough.

Gateshead Football Club, 1953

Players shown training at Redheugh Park include Jack and Tom Callender, two brothers who between them made 910 league appearances for Gateshead – a record for two brothers at the same club. In 1953, the team achieved remarkable success getting to the quarter-finals of the FA Cup where they lost to Bolton Wanderers at Redheugh Park.

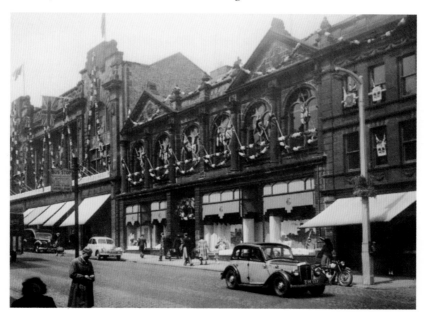

Coronation Celebrations at the Co-op, 1953

The Coronation provided an excuse for celebrations throughout the country and Gateshead was no exception. Here, the Co-operative stores on Jackson Street are shown bedecked with flags and garlands of flowers. This photograph was taken by local historian and journalist Clarence Walton on 2 June 1953 – the day Queen Elizabeth II was crowned.

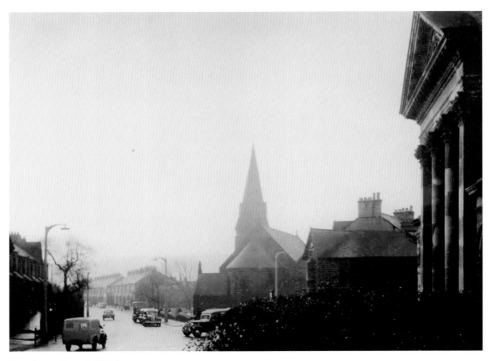

Bensham Road, 1954
Even in the 1950s, Bensham Road was a busy area. St Cuthbert's church is pictured centre with the imposing Wesleyan Methodist Church at the right of the photograph. On the left-hand side are the steps leading up to a private gated street, West View Terrace.

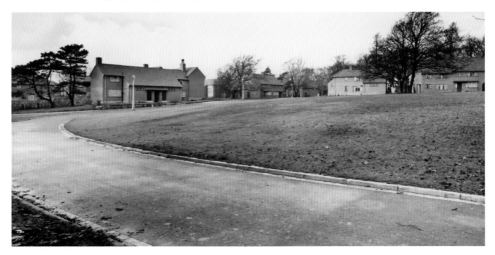

Cedars Green, *c.* 1954
This was intended to be a prestigious development social housing. The fifty-nine houses cost £87,000 to build and the estate was pleasantly laid out around two circular greens. A spacious layout and attractive landscaping added to the appeal. However, the limited number of houses did not really make a significant contribution to solving Gateshead's housing problem and so the estate's design was never repeated.

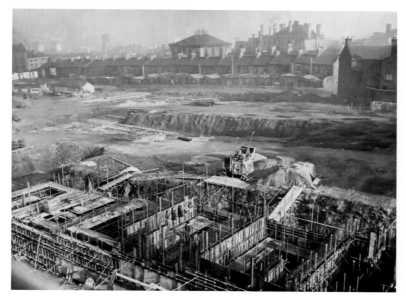

Construction of Adelaide Court, *c.* 1955

One of the 1950s answers to Gateshead's vigorous programme of clearing slum housing, was to build high-rise blocks of flats. Adelaide Court was part of the first scheme at Barns Close and work was completed in 1956. In the background of the photograph can be seen the rear of Melbourne Street, the tower of St Mary's church and the former Bethesda chapel, where William Booth once preached.

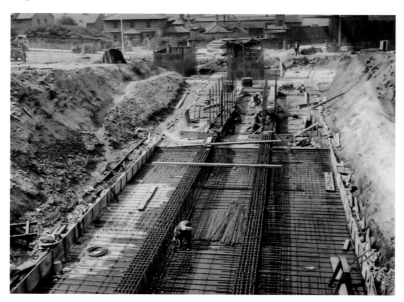

Construction of Brisbane Court, Barns Close, *c.* 1955

Altogether, four blocks of flats were built at Barns Close containing 196 dwellings with each block being named after a different Australian city. The total cost was £548,141 11*s* 6*d* – quite a substantial sum for the time. In the background, from left to right, can be seen the Victorian-built Greenesfield House and Greenesfield clinic, with its distinctive curved Art Deco-styled window.

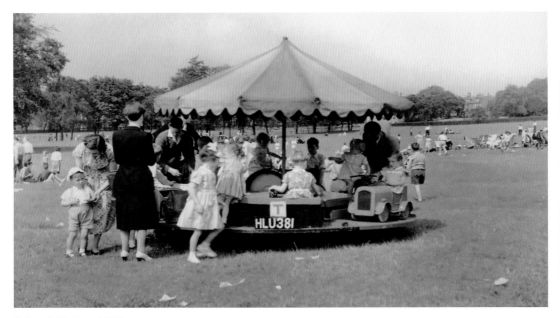

Saltwell Park, *c.* 1955

Saltwell Park opened in 1876 and continued throughout the twentieth century to provide a popular place for recreation. The small roundabout, complete with car registration plate, pictured, is being well used by children. However, even into the 1950s, only in the summer period could activities such as this take place on Sundays!

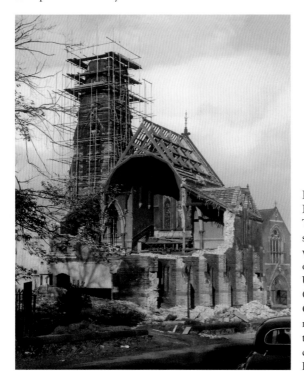

Presbyterian Church, High West Street, 1956

This church was built in 1877 and was situated on High West Street at the junction with Gladstone Terrace. This site, because of the proximity of two other churches, the United Methodist Church and the Baptist Church, became known locally as Amen Corner. Falling congregations eventually meant the church closed and it was sold to Gateshead Council in 1940. It was demolished in 1956 and the Five Bridges Hotel was later built on the site.

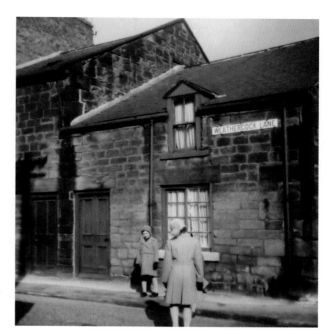

Weathercock Lane, Low Fell, 1957
Weathercock Lane was situated off
Kells Lane in Low Fell. Many of
Low Fell's early houses were stone
built as can be seen here with the
stone being supplied from any one
of the numerous quarries in the area.
Weathercock Lane still remains today
but the houses shown here have been
demolished.

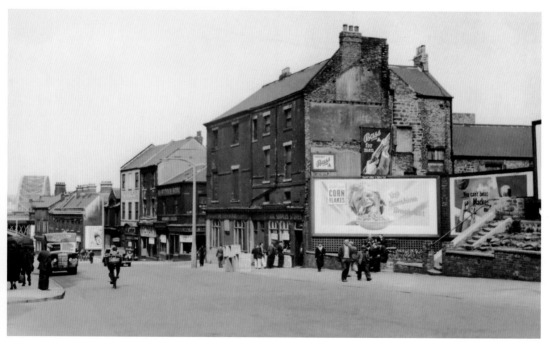

High Street, 1959
Many shops at the bottom of the High Street had been demolished in the 1920s for the building of
the Tyne Bridge approach road. During the 1950s more would go in order to create space for a new
traffic roundabout, which was part of the work necessary for the creation of the Felling bypass. This
photograph shows some of those to be demolished including Hunter's the tobacconists and the Grey
Horse public house.

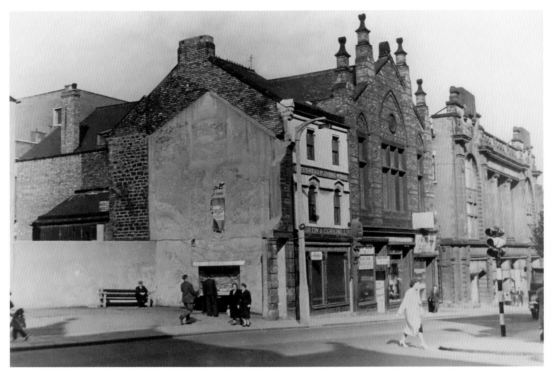

Jackson Street, 1959

The vacant site at the corner of Jackson Street and West Street would later be occupied by yet another Co-op building (the Co-op store built in 1925 can be seen here, an older store is further down Jackson Street and is off the photograph). The first shop shown here is that of Cortin & Corking, plumbers merchants.

Construction of Felling Bypass, Park Road, 1959

The Felling bypass was a major new road development begun at the end of the 1950s. However, to call it a bypass was technically incorrect as it did not 'bypass' Felling but rather cut straight through it. This caused real problems for many local residents and in the early days there were frequent accidents and a number of fatalities.

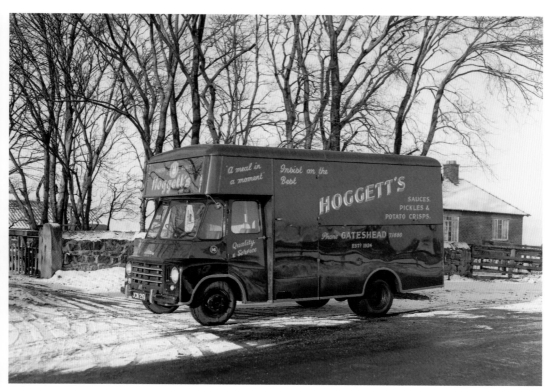

Hoggett's Crisps New Van, 1959
John William Hoggett, originally from Sunderland, established Hoggett's Food Products in 1924. These product were produced in the firm's factory situated at the junction of Redheugh Bridge Road and Bank Street. Hoggett's are credited with introducing the first flavoured crisp (salt and vinegar) in the 1950s.

Chapter 7

1960–1969

The 'swinging sixties' was the era of the Beatles, mini-skirts and a new free popular culture. It also saw the assassination of President J. F. Kennedy and the death of Sir Winston Churchill. In Gateshead this was a period of town-centre development and, in 1965, work began on the foundations of a brand-new 'state-of-the-art' shopping centre. 1968 saw the centre opened with fifty-two shops and three department stores. New housing estates were built, some with innovative designs, such as the 'butterfly' houses at Allerdene.

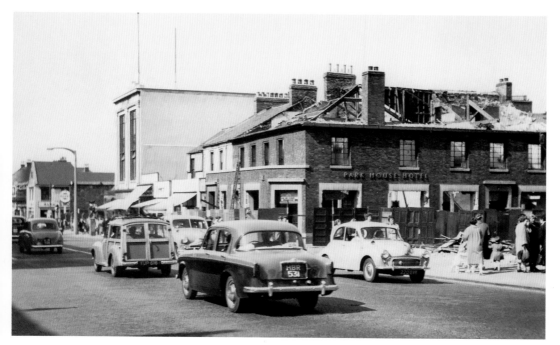

Park House Hotel, 1960

The Park House Hotel, one of Gateshead's many Victorian public houses, met its end when a road-widening scheme was approved for the High Street/Park Lane junction. The tall building shown was Doggart's department store which would close.

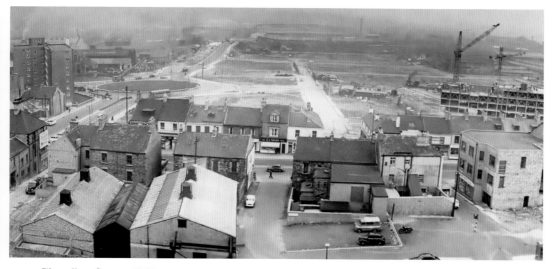

Chandless Street, 1960

Both old and new Gateshead are shown here. In the background is the new roundabout, created as part of a new road system. The Chandless area was made up of a grid pattern of tightly packed and poorly built houses. A new estate was built to replace these houses; the first phase comprised three sixteen-storey tower blocks. The new estate didn't last as long as those houses it replaced, as it was demolished in 2013/14.

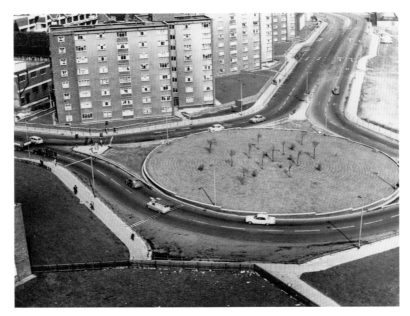

Park Lane Roundabout, 1960

Here is an aerial shot of the Park Lane roundabout shown in the previous photograph. It was such a novelty in Gateshead that it even appeared on a postcard! Within a few years, this whole scene would change with the construction of the Gateshead viaduct.

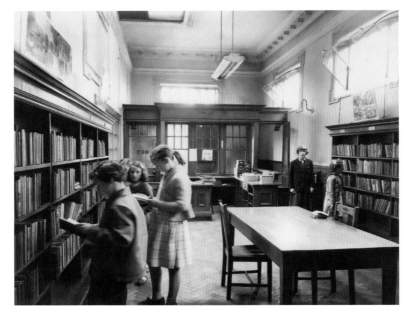

Children's Library, Central Library, c. 1960

Until taking over part of the old reading room some years later, the children's library was always small. Misbehaviour here was severely discouraged! Wooden gates ('in' and 'out') controlled access and children were restricted in what they could borrow – having first had to pass a reading test (from the age of five upwards) to make sure they were reasonably proficient readers.

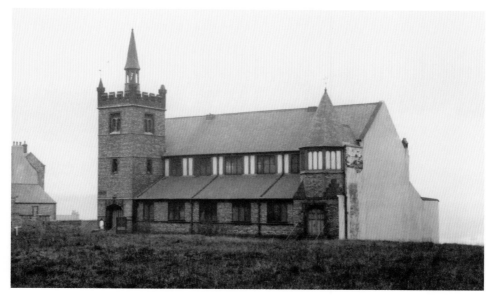

Presbyterian Church, Park Terrace, Windmill Hills, 1963

The 1960s saw a fall in churchgoing and a number of churches were closed and subsequently demolished – this church was one of them. It opened on New Year's Day 1889 and the congregation grew during the early years of the twentieth century but gradually the number of churchgoers dwindled and the church closed in 1963. One year later it was demolished.

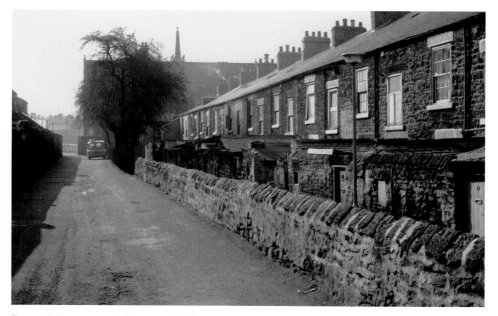

Rear of Ravensworth Terrace, 1963

This proved a rather unique street as, after its demolition in the 1970s, some houses were rebuilt as a terrace in Beamish Museum's town. In this photograph, the spire of Park Terrace Presbyterian church (demolished in 1964) can be seen peeping above the rooftops of Bensham Road. The houses were built between 1835 and 1841; one early resident was John Wilson Carmichael, the marine painter.

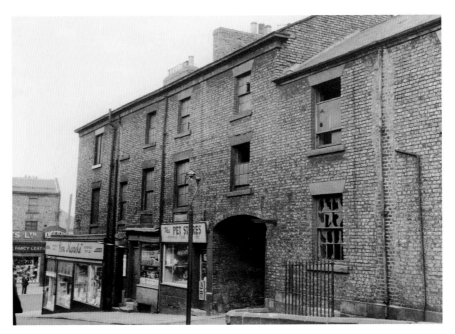

Shops on Ellison Street, *c.* 1963

Before the construction of the new Gateshead shopping centre, these were typical of some of the smaller shops that existed running off the High Street. They included Bon Marché and the Pet Stores. On the High Street, Knott's shoe shop can just be glimpsed.

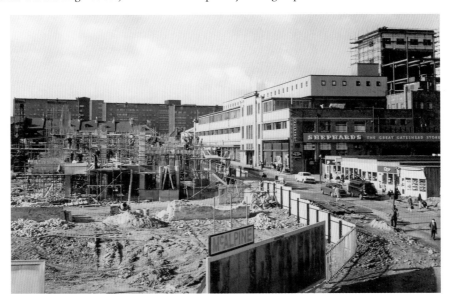

Ellison Street, *c.* 1965

Shephard's new store, which opened in 1951, is prominently shown here but rising alongside is Gateshead's new Trinity Centre – planned to attract shoppers from 'over the water' in Newcastle. Sadly, virtually as soon as it was completed, the Gateshead Highway (the present A167) was constructed, effectively taking people away from Gateshead by improving fast access to Newcastle.

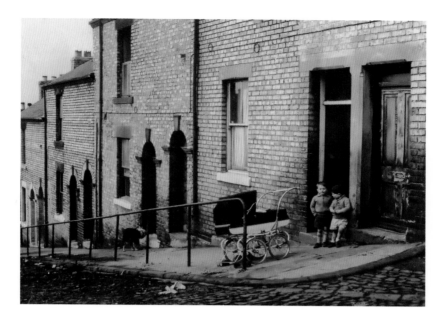

Frederick Street, c. 1965

Not many streets are so steep that you need the help of a handrail to walk up or down. Note the pram, precariously situated on the steep slope, which has had to have chocks placed under the wheels to avoid a downhill accident. This street, and others equally steep alongside it, were demolished in the late 1960s and the innovative, but sadly flawed and short-lived, St Cuthbert's Village development was built on the site.

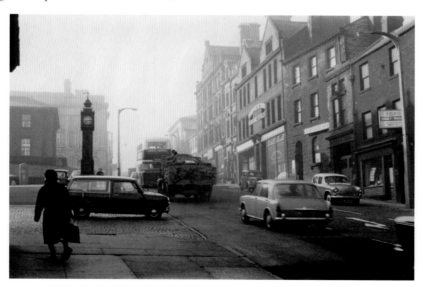

Traffic on West Street, c. 1965

As car ownership became more popular, and before roads were built which would take traffic away from Gateshead town centre, traffic build-ups were common. West Street could become a bottleneck as this photograph, taken during the morning rush hour, shows. All the shops on the right of the photograph would be demolished during the 1970s.

Jackson Street, *c.* 1966

For a period in the 1960s, Jackson Street was closed to traffic with these traffic bollards operating as a definite deterrent to erstwhile motorists. Traffic signs painted on the road surface east and south are a reminder of the routes which could previously be taken. Thankfully, the street was eventually opened to all traffic again.

Boilermakers Club, 1968

This building opened in 1968 as a social club for members of the Boilermakers Union with seating for 1,500 and was situated at the junction of Charles Street and West Street. It was taken over by local comedian Bobby Pattinson in 1978 and renamed 'The Talk of the Tyne'. Bobby brought some international entertainers here including the singers Matt Monro, Tony Christie and Lonnie Donegan. The building was eventually demolished in 2006.

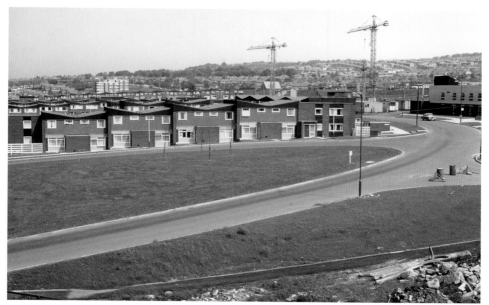

Harlow Green Housing Estate *c.* 1968
These distinctive 'butterfly-style' houses were built at Allerdene and also at Harlow Green in the late 1960s. Although an innovative design, the distinctive roofs were never repeated in future Gateshead housing schemes.

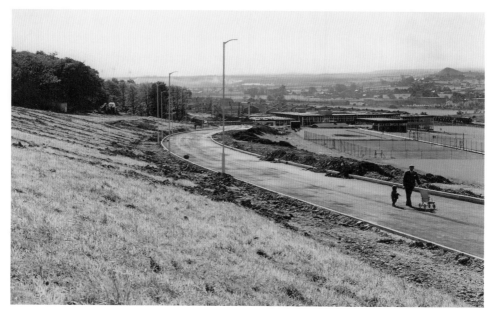

Saltwell Road South, *c.* 1968
Today this road is a busy main road but in this photograph, taken in the late 1960s, the road has just been extended linking the new estates off Chowdene Bank and Allerdene directly with the Saltwell area. The then new Breckenbeds School (now Joseph Swan Academy) can be seen in the background.

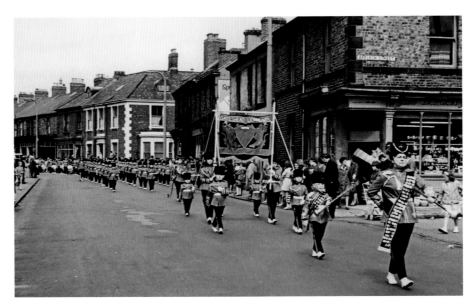

Marching Band on Alexandra Road, *c.* 1968
In the 1960s, '70s and early '80s marching bands were a common feature in towns and it was many little girls' dream to become a baton twirler. The Gateshead Lionhearts was just one of a number of bands in Gateshead; others included Gateshead Grenadiers and the Carr Hill and Sheriff Hill Lancers. Competitions were frequently held, which were often attended by thousands of spectators.

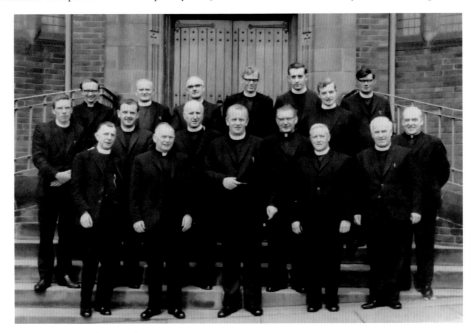

Priests at Corpus Christi Church, 1969
Corpus Christi School, which opened on 2 June 1909, celebrated its sixtieth anniversary with a special celebration mass at Corpus Christi church. The mass was led by parish priest Father Pat McKenna who was assisted on the altar by fourteen other priests, all former pupils of the school.

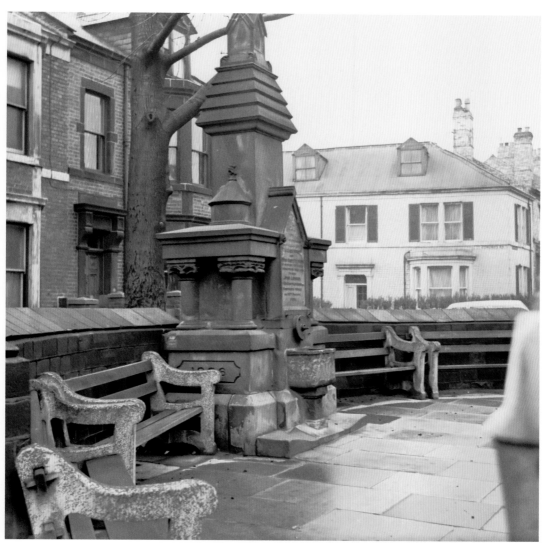

Lennon Memorial Fountain, North End of Durham Road, 1969
The fountain, shown here shortly before its removal to Beamish Museum, was a casualty of the newly constructed Gateshead Highway. It commemorated a tragic accident when a little boy, John Lennon from Felling, fell around 15 feet down a ventilation shaft on 9 August 1886 while playing with two of his friends.

Chapter 8

1970–1979

A decade that saw the introduction of decimal currency and Margaret Thatcher becoming Britain's first female Prime Minister when the Conservatives swept to power in 1979. But it was also a decade dominated by strikes and trade union action, with power cuts a regular occurrence.

Locally, Gateshead's new road, the A1 viaduct, was formally opened. This effectively took people away from the town's brand-new shopping centre. In central Gateshead, little of the old town remained having largely been swept away in the previous two decades. Overpowering the town was the car park, which came to prominence in the Michael Caine film *Get Carter*.

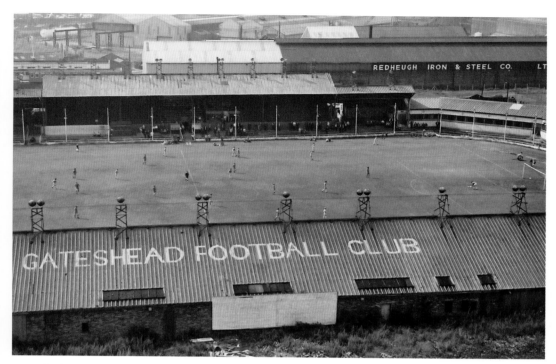

Redheugh Park, 1 August 1970
This shows a match taking place in front of a sparse crowd of spectators between Gateshead and Brechin City, a match which Gateshead won 4–0. Redheugh Park opened in 1930; however by the 1960s Gateshead AFC were in trouble having lost their football league status. Eventually, Redheugh Park fell into disuse and was demolished in 1973. The football club went into voluntary liquidation the same year.

Construction of the Gateshead Highway, 1970
Major roadworks are photographed here with the construction of the Gateshead flyover, a highway which was meant to link seamlessly to Newcastle but was never completed. It took traffic past Gateshead's town centre but then ended in a series of traffic lanes which narrowed en route to the Tyne Bridge. The Belle Vue roundabout can be seen at the bottom of Old Durham Road.

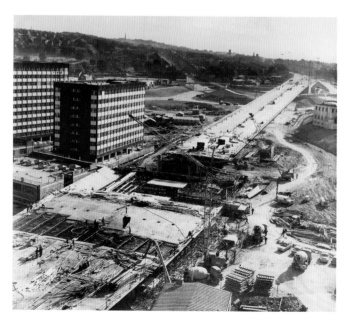

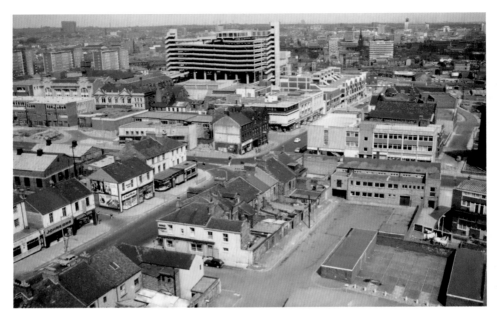

Trinity Square, 1970

This view is of the centre of Gateshead, looking north down the High Street to the newly built Trinity Square shops with the *Get Carter* multi-storey car park dominating the scene. The stylish fronts of the Co-operative store can be seen just in front of the car park.

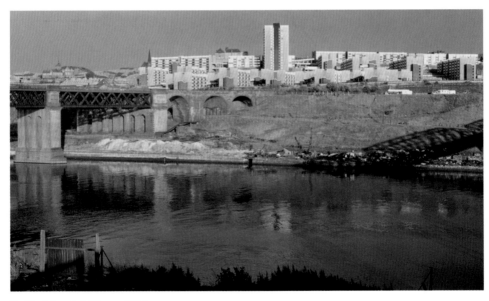

St Cuthbert's Village, 1971

The award-winning St Cuthbert's village was intended to be both a showpiece development and also an entirely self-contained village with blocks linked by walkways. There was one tower block that was seventeen storeys high; while other accommodation was built in what were referred to as 'scissor blocks' complete with roof gardens. However, it soon became a marooned and isolated development and within thirty years, the village was demolished.

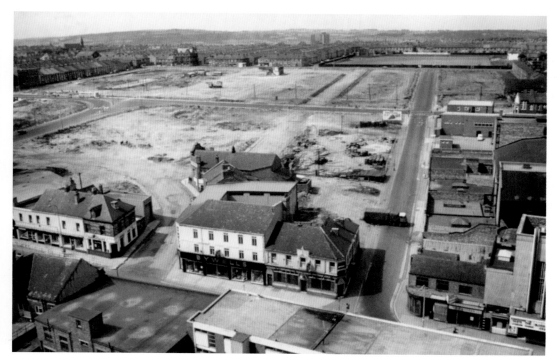

Ann Street and High Street, 1971
By the time the demolition contractors had done their job, there really was very little of old Gateshead left standing as this photograph of the south end of the High Street shows. The tall building, bottom right, was the Odeon Cinema. Bywell's store is clearly visible in the centre of the photograph while the ground shown at the top right is the North Durham Cricket ground.

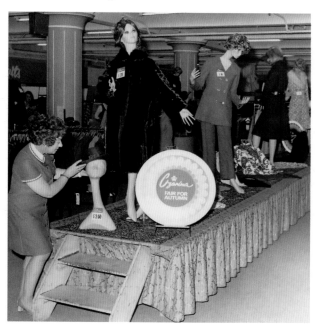

Shephard's Autumn Fair,
September 1971
Shephard's had their own advertising jingle which began 'Shephard's of Gateshead, the biggest and the best store, Shephard's of Gateshead, find what you're looking for ...' and there was certainly no problem finding ladies clothes here. An assistant carefully adjusts a hat from the Czarina range. Coats (including a fur coat) and a rather trendy trouser suit are also displayed on the dais.

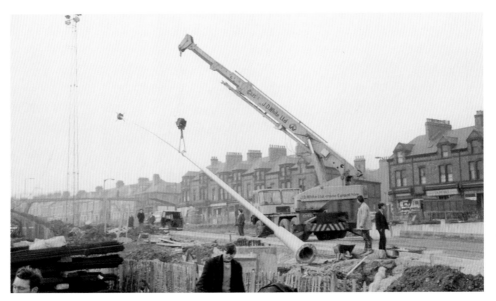

A1 Viaduct, 1971
Here, giant lamps are being erected near to the Belle Vue roundabout at the southern end of the new viaduct. The block of flats and shops to the left of the crane were demolished in later years to be replaced with a block of purpose-built apartments, without the shops. The shops to the right also went, but were converted into flats and not demolished.

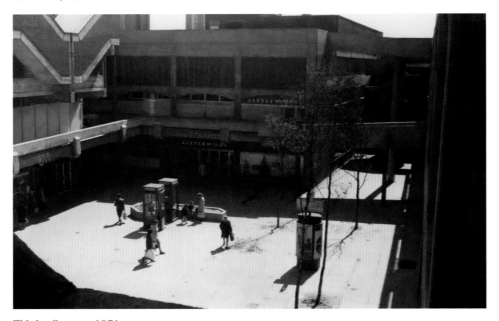

Trinity Square, 1971
Although the new shopping centre had actually opened three years earlier, by 1971 only fifteen out of fifty shop units were occupied. One of the most successful of these shops was Littlewoods although the main frontage of the shop was on the High Street. The amount of concrete used in construction gave the centre a stark appearance.

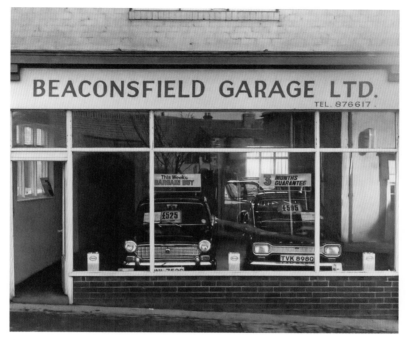

Beaconsfield Garage, Beaconsfield Road, Low Fell, 1972

A reminder of the days when £595 bought you a second-hand Ford Escort with a three-month guarantee or, alternatively, you could buy a used Austin 1100, classed as the week's bargain buy, for £525. This building still stands but is now an estate agent's.

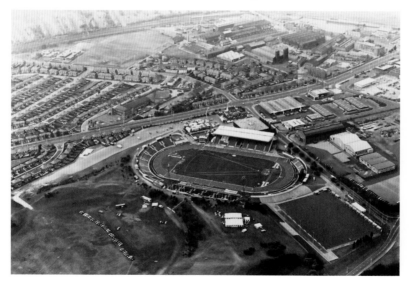

Gateshead International Stadium, 1974

Originally opened as Gateshead Youth Stadium in 1955 the stadium has been extensively redeveloped on three occasions and now has a capacity of around 11,800. Much of the credit for its success lies with the Olympic medal-winning athlete, Brendan Foster, who inaugurated the Gateshead Games in 1974 when in charge of the council's sports and leisure department.

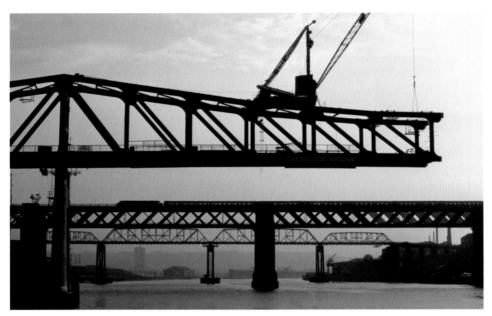

Queen Elizabeth II Metro Bridge under Construction, May 1978

This bridge was built to carry the Metro light railway over the Tyne and was begun in 1976. It was designed by W. A. Fairhurst and Partners and built by Cementation Construction Ltd and the Cleveland Bridge and Engineering Co. Like the Tyne Bridge the steel girder construction was built out from opposite banks. The bridge was officially opened by the Queen on 6 November 1981 and nine days later, the new regular Metro services started running.

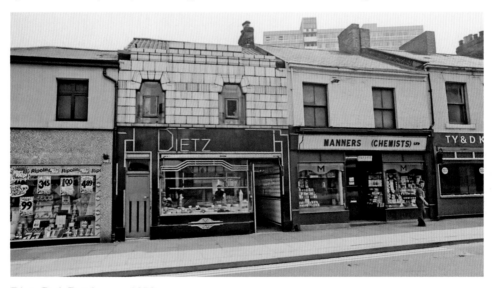

Dietz Pork Butchers, *c.* 1978

With its distinctive green-and-cream-tiled exterior, which was added in the 1930s, Dietz's shop was a landmark at the south end of the High Street. In common with many other German pork butchers, the Dietz family came to Gateshead at the end of the nineteenth century and settled here, their business quickly becoming established.

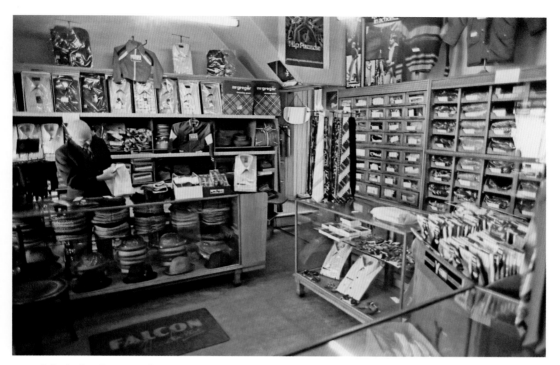

Men's Outfitters on Coatsworth Road, 1978
Even in Gateshead's 'brave new world' of Trinity Square, there was still a place for the traditional shop.
The latest men's trousers, 'Evvaprest', are advertised here but these were the days when shirts were still
largely selected from stock that was housed in glass cabinets. Note the wide selection of cloth caps in
the display cabinet – an essential piece of headgear for Gateshead men in the '70s!

Queen's Terrace, 1979
Here, a dual carriageway is being
constructed over the gardens
belonging to Regent Terrace on
the right, although the gardens of
Queen's Terrace, on the left of the
photograph, are still in evidence. They
too would later be removed, along
with Queen's Terrace itself, to make
way for the Civic Centre. The Central
Methodist Hall to the left was also
demolished and the terrace of houses
looking down the dual carriageway
would soon be replaced by a large
roundabout.

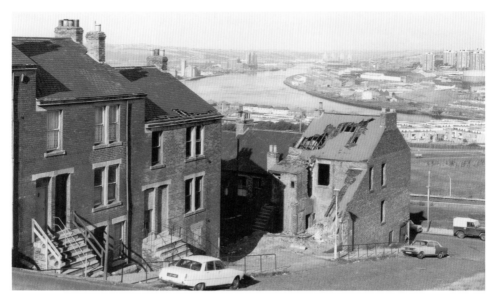

Gordon Street, 1979

This photograph taken on 2 September 1979, shows Gordon Street, which was one of a series of steep streets leading down to the river. Note the bricks placed in front of the tyres of the light-coloured car in case of brake failure.

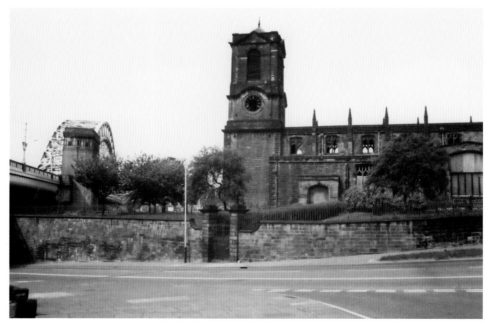

St Mary's Church, 1979

In 1979 fire swept through St Mary's, Gateshead's oldest church, destroying much of the interior fitments and stained glass. Only limited repairs were carried out and four years later, disaster would strike again when a further fire broke out. This was Gateshead's 'mother church'; it had been the only one in town until 1825 and had a long and illustrious history.

Chapter 9
1980–1989

The country's excitement at the marriage of Prince Charles and Lady Diana Spencer in 1981 was short-lived as 1982 brought national unemployment and Britain went to war with Argentina over the Falkland Islands. The miners' strike began in March 1984, and Margaret Thatcher was re-elected for a second term in 1983 and again for a third term in 1987.

In Gateshead there were royal visits by Queen Elizabeth II in 1981 and Diana Princess of Wales in 1983. The Royal Shakespeare Company performed here in 1986, and 1983 brought fire and gale damage to two historic buildings. A new high-level bridge at Redheugh was opened to ease the traffic congestion of the Tyne Bridge and a new Civic Centre was opened.

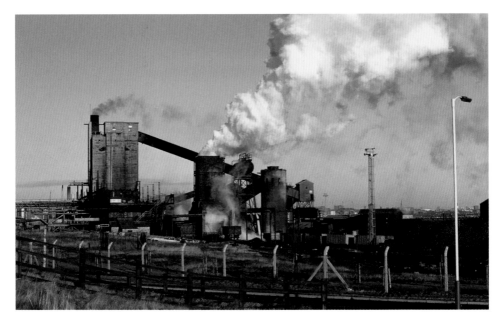

Norwood Coke Ovens, 1980

In 1912, a coking plant was built by the Team By-Product Coke Co., near to the northern end of the present-day Team Valley Trading Estate. It was connected by a private railway to the Ravensworth Colliery Co. and Dunston Staithes. The coke works closed in 1983 and the site later became part of the area developed for the 1990 Gateshead Garden Festival.

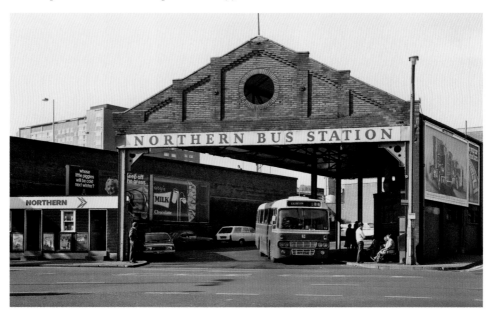

Wellington Street Bus Station, 31 July 1980

This station, once a hive of activity, was soon to become redundant with the construction of the new bus and Metro interchange complex located on West Street. By 1985 it was a shell ready for demolition.

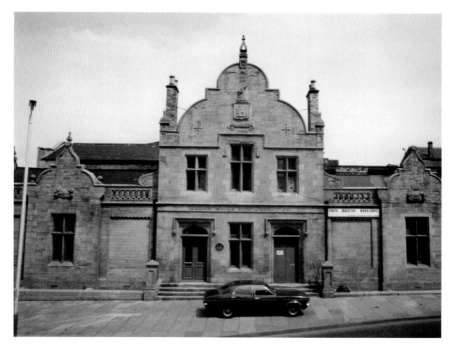

Oakwellgate Baths, 1980

Destroyed by fire in 1986, this building had stood on the site since 1854. Designated as Oakwellgate Public Baths and Washhouses, the building cost £4,300 and was designed by the borough surveyor, William Hall. The laundry facilities were well used, but the baths, due to their relatively high cost (*6d* for a hot bath), were less so. Today the site of the baths is now the coach park for The Sage, Gateshead.

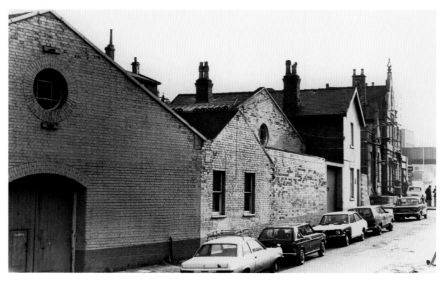

Rooney's Scrapyard, Oakwellgate, 1980

Rooney's scrap-metal company was established in 1904 and had premises situated on Oakwellgate, just down from Oakwellgate baths. Rooney's bought all grades of scrap materials and they still operate their scrap-metal business not far from this building on South Shore Road, Gateshead.

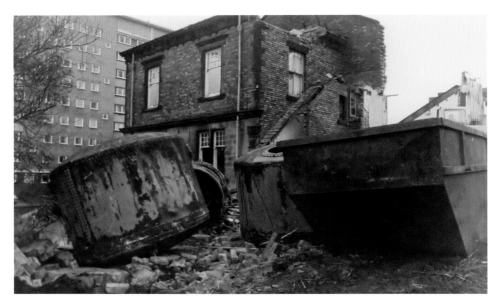

Demolition of Caretaker's House, High West Street, 1980

Here, the caretaker's house for the Central Hall is being demolished. The Central Hall (once the High West Street chapel), was demolished to make room for the building of a new Civic Centre opposite Regent Court flats.

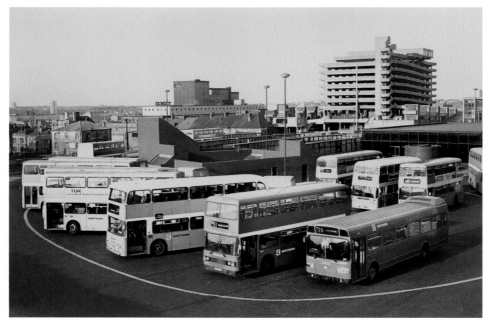

Gateshead Bus and Metro Station, April 1982

In 1971, transport planners devised a light rail solution for urban transport integration, which was agreed by the Government in 1972. Construction got underway in 1974 with tunnels driven beneath the streets of Gateshead. Trains began running in 1980 and the Gateshead Interchange bus and Metro station was officially opened by the Queen in 1981.

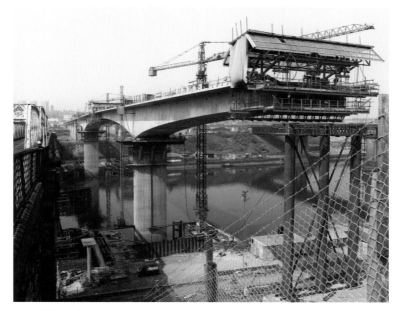

Construction of New Redheugh Bridge, 1982

This new bridge was built just 25 metres away from the earlier bridge. Designed by Mott, Hay & Anderson, work began in 1980. It was built of concrete with four traffic lanes and one footpath. The bridge cost £15,350,000 and was opened on 18 May 1983 by Diana, Princess of Wales. The old bridge remained in use until the new one opened and then dismantled.

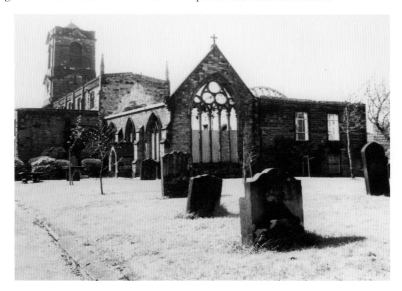

St Mary's Church Damaged by Fire, 1983

Further damage was caused to St Mary's church in 1983. On this occasion the roofs to the chancel and anchorage were completely destroyed. The anchorage, which had survived as a school since at least the seventeenth century, had to be demolished. Eventually, the building was restored and used initially as an auction house and then as a visitor centre. Today it is home to St Mary's Heritage Centre.

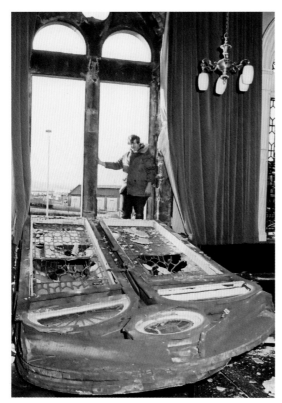

Gateshead Old Town Hall, 1983
Keith Gilhespy, from Gateshead Council's
Public Works department surveys the damage
at the Old Town Hall caused when strong
winds blew in a window weighing 3 tons.
The storm took place on 17 January 1983,
just fifteen minutes after the end of a
committee meeting. The window was one
of a set that Sir John Maccoy gifted to
the building in 1930.

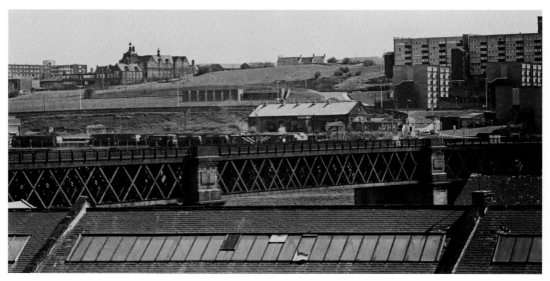

Windmill Hills, 1983
Taken from Newcastle with the King Edward VII rail bridge in the foreground, this shows Windmill Hills
Industrial School with a smaller infant school attached at the left of the photograph and, at the right, the
eastern section of St Cuthbert's Village. The green space in the centre of the photograph was originally
Gateshead's first park and, within a few years of this photograph being taken, would be fully restored.

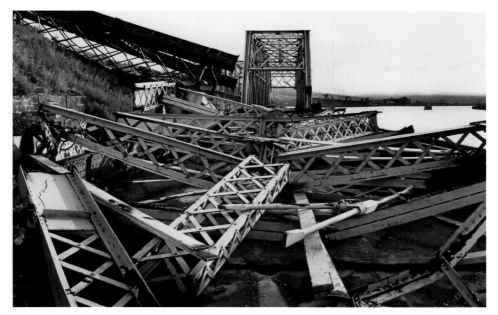

Demolition of Old Redheugh Bridge, 1984

Old Redheugh Bridge was never a complete success, with speed restrictions of 10 mph and weight restrictions between 8 and 10 tonnes, which hindered traffic. Another problem was that the clearance height did not allow for double-decker buses to be used. It was easier to build a new bridge rather than upgrade the old, which was taken down in sections and laid on the south bank of the river for subsequent removal.

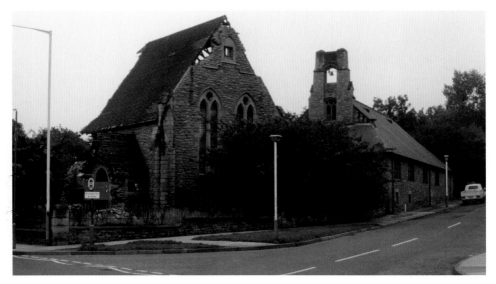

Venerable Bede Church, Sunderland Road, 1984

Storm damage meant the end of this church, which had stood on the corner of Wordsworth Street and Sunderland Road since 1885. The damage was so extensive that the church proved uneconomic to repair and was demolished in the late 1980s. The congregation merged with that of another demolished church (St James) and now meet in the church hall on Wordsworth Street.

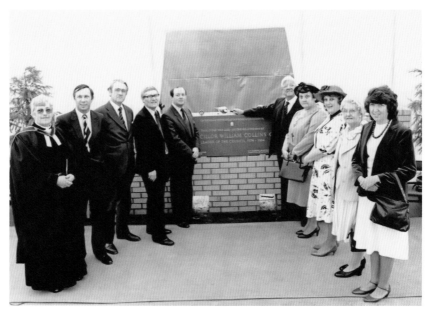

Laying the Foundation Stone of the Civic Centre, Regent Street, 1984
Cllr William Collins laid the foundation stone of Gateshead's Civic Centre on 6 June 1984 shown here, back right. Back left is David Clelland, Gateshead's MP at the time. In January 1987, the building was opened by the leader of the Labour party, Neil Kinnock. The building cost £29 million and was to bring the council's main departments under one roof for the first time since local government reorganisation in 1974.

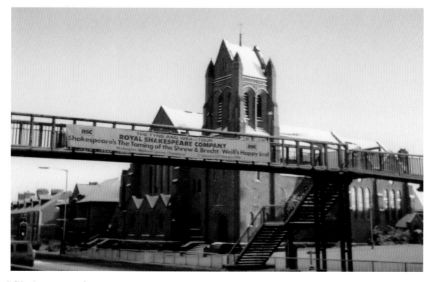

Royal Shakespeare Company, 1986
The photograph above shows the banner tied to the footbridge at Shipcote advertising performances by the Royal Shakespeare Company who came to Gateshead in January and February 1986. Their visit was part of a Tyne and Wear tour and the venue was Gateshead Leisure Centre where they performed Shakespeare's *The Taming of The Shrew* and Brecht/Weill's *Happy End*.

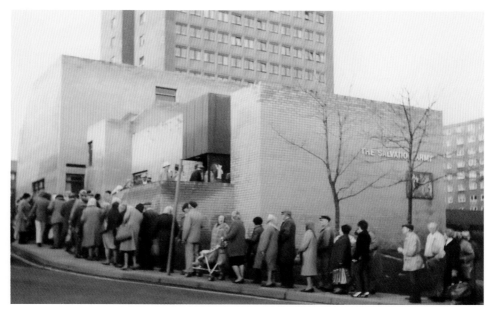

First Butter Queue at Salvation Army Building, 1987

Since the early 1970s farmers in EU countries had been encouraged to produce large amounts of dairy products, which appeared lucrative but became difficult to sell resulting in what was referred to as 'butter mountains'. The photograph shows a queue of people outside the Salvation Army building on Warwick Street waiting to get some butter, either free or at a low price.

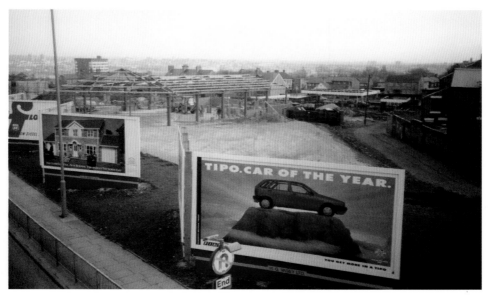

Construction of Citroën Garage 1989

The former site of the Abbott Memorial School (later Thompson's Red Stamp store) had been cleared during the construction of the flyover. The left of the photograph shows the construction of the Citroën Garage off Durham Road. The large billboards are advertising luxury housing in the north-east and the Fiat Tipo, which was car of the year in 1989.

Chapter 10

1990–1999

The 1990s brought huge political change to the country after the Government's plans for a 'poll tax' sparked riots – Margaret Thatcher resigned in November 1990. In April 1992 John Major returned as Prime Minister in the general election with a slim majority until May 1997 when Tony Blair became Prime Minister after Labour won the general election. The Channel Tunnel opened in 1992; the first women priests were ordained by the Church of England in 1994; and Princess Diana died in a car crash in Paris in 1997.

In 1990 Gateshead held the fourth National Garden Festival, which provided the impetus for a host of public art projects and sculptures across the town as well as a private housing estate built on the site of the festival after it closed. Later in the decade, Saltwell Park would be awarded a major grant from the Heritage Lottery Fund, which would enable the park to be restored to its Victorian splendour in the following decade.

National Garden Festival Gateshead, 1990
The festival was held between May and October 1990, lasted 157 days, and received over 3 million visitors. The festival site was created on 200 acres of derelict land, previously the site of a gasworks, a coal depot and a coking plant. After the festival ended, much of the site was replaced by housing. Attractions included public art displays, a ferris wheel, dance, music, theatre and sporting events. Several modes of transport were provided around the site: a monorail, a narrow gauge steam railway and a road train.

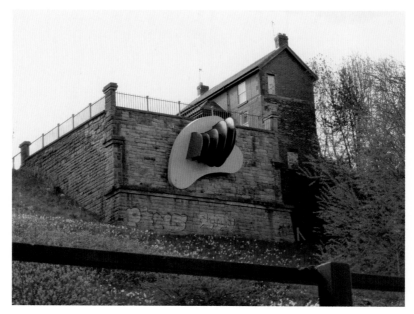

Once Upon a Time Artwork, 1990
The artwork *Once Upon a Time* is built onto the abutment of the demolished Redheugh Bridge approach road. It was designed by Richard Deacon who was inspired by the architecture of the surrounding environment, making links with past industries along the Tyne. The old toll house can also be seen in the photograph.

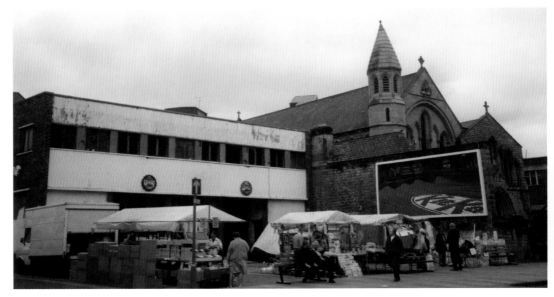

Market Stalls, High Street, *c.* 1990

Here stallholders take advantage of an unused piece of land next to Holy Trinity church on Gateshead High Street. The derelict garage premises behind the market stalls were demolished in 1992. The old stone wall to the left of the advert is the remains of part of the Ellison School building, onto which Holy Trinity church was built in 1897.

Avenues House, Brinkburn Avenue, 1991

The Avenues project was one of many Gateshead Council art projects that were undertaken during the 1980s and '90s. This photograph taken in July 1991 shows the exterior of a house that was decorated inside and outside by artist Keith Alexander. The house was open to the public and inside were carved wooden sculptures of everyday furniture and people.

Gateshead Metro Interchange, West Street, 1992

A quiet West Street can be seen here at the junction with Walker Terrace and Jackson Street in February 1992. To the left are the railings of St Joseph's church and on the right is the New Century House Co-operative building. The tall brick building just off centre is the Interchange building, which would change completely when the Metro station was redeveloped in 2003/04.

South Street School Under Construction, 1993

A new South Street school was built alongside the old school and opened to primary school pupils in September 1993. The old building, which was used from 1882–1993, was demolished soon afterwards. The official opening ceremony on the 27 January 1994 was performed by the Mayor of Gateshead, Cllr Sid Henderson.

Park House, Clarke Chapmans, 1995

After a succession of owners, Park House was bought by Clarke Chapman's in 1882 and converted into offices. In November 1891 it was gutted by a severe fire and was reconstructed internally. Here Charles Parsons experimented with early turbine engines. Following another fire, the building was later demolished and the land is now the location of St James' housing development.

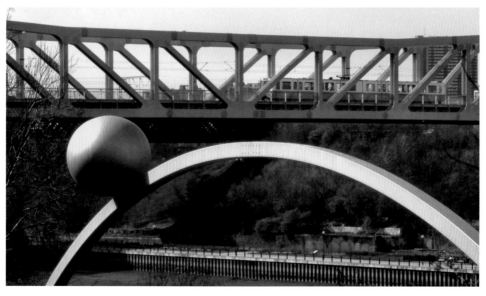

Rolling Moon, 1995

Taken in February 1995 this photograph shows a Metro train crossing the Queen Elizabeth II Bridge over the River Tyne. In the foreground is the *Rolling Moon* sculpture at Pipewellgate. The curved steel sculpture represents the moon's effect on the oceans' tides in relation to maritime history and was designed by Colin Rose in 1990.

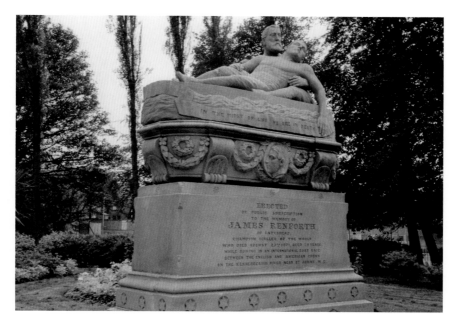

Renforth Memorial, Prince Consort Road, 1996
This photograph shows the Renforth Memorial outside the Shipley Art Gallery. James Renforth was the best and most famous local Victorian rower but tragically died following a race in Canada in 1871. His body was brought home to Tyneside and he was buried in St Edmund's Cemetery, Gateshead, where this memorial originally stood. It was claimed that 100,000 mourners attended his funeral.

Bank Road, October 1997
Bank Road was a narrow steep street which led down to Hillgate from the junction of Oakwellgate and Abbot's Road. The warehouses on the right-hand side have seen years of industry and manufacturing – this was about to change, as the site is now the location of The Sage Gateshead, which opened in 2004.

The Half Moon Public House, Half Moon Lane, 1997
This was one of Gateshead's last remaining eighteenth-century buildings but eventually had to be demolished as the structure became unstable. At the other end of Half Moon Lane was yet another Half Moon public house and so this building was often referred to as the High Bar. Curzon Place apartments now occupy the site.

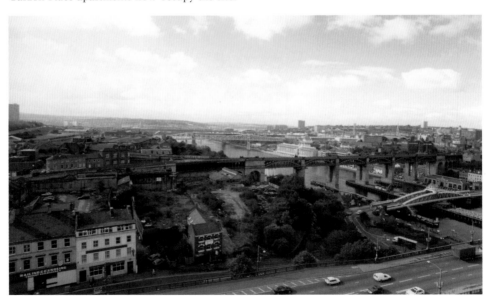

Bottle Bank and the Tyne Bridges, 1997
The Swing, High Level, Metro and King Edward bridges can all be seen here. The two large buildings on Bottle Bank are the sailing and canoeing manufacturers and the Queen's Head. The smaller three-storey building, number No. 36 Bottle Bank, had been a tobacco pipe manufactory. These were all demolished to make way for modern housing and the Hilton Hotel.

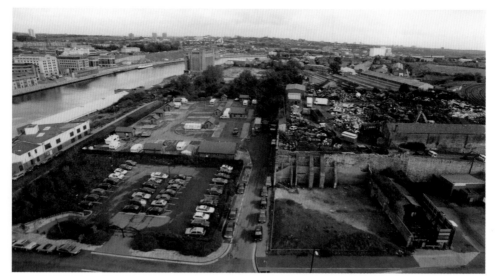

Jennings Scrap Yard and Baltic Flour Mill, 1997
This view looks north-east over Jennings' Scrap Yard and a travellers' site. The area had earlier been the location for Gateshead's first railway station on the Brandling line of which only the steep ramp and stone wall remain. This is now the site of The Sage Gateshead and car park. Beyond the travellers' site is the Baltic Flour Mill, soon to become the Baltic Centre for Contemporary Art.

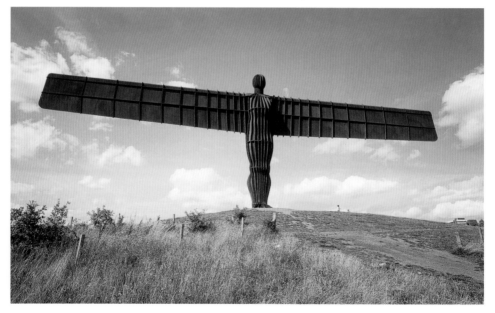

The Angel of the North, February 1998
The Angel is located at the southern end of Gateshead overlooking the A1 and A167. Designed by Antony Gormley, the Angel is constructed of steel and is 20 metres tall, with wings measuring 54 metres across. The site chosen was formerly part of Team colliery, so foundations containing 600 tons of concrete anchor the sculpture to rock 21 metres below, and due to its exposed location, the sculpture was built to withstand winds of over 100 mph.

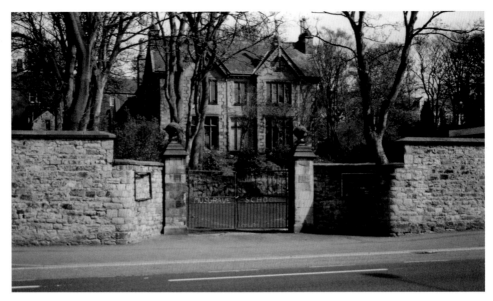

Musgrave School, Durham Road, Low Fell, 1999

In 1919 Musgrave was purchased as a private day school, run by Alice and Florence Evelyn Elliott. The school was later left to their nephew who sold it to a consortium of parents who ran it for a while; it was then taken over by one owner, but closed 19 August 1999. Musgrave has been a Grade II-listed building since 1 November 1982. In April 2005 it was renovated into residential apartments.

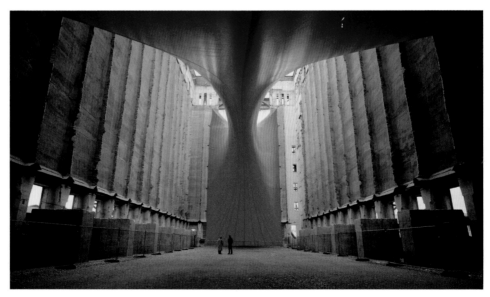

Taratantara, 1999

The warehouses of the Baltic Flour Mill were demolished in the 1980s but the silo remained. After a competition in 1994, it was decided the building should be converted to a Centre for Contemporary Art. The interior was removed as were the east and west walls leaving a void in the centre. The first artwork displayed in the void was a giant red structure called *Taratantara* by Anish Kapoor.